IMAGES
of America

THE TURQUOISE TRAIL

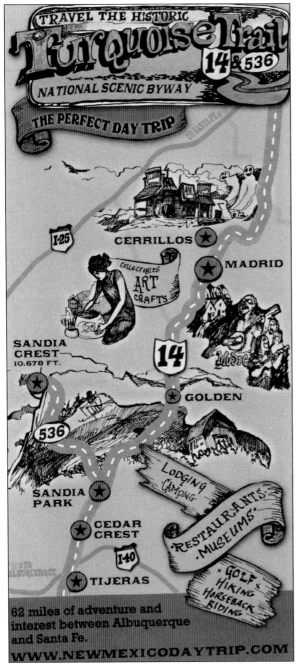

New Mexico artist Ross Ward created this map in his distinctive style. Ward, a self-taught and prolific outsider artist, spent over four decades carving and constructing wooden figures that he exhibited at county fairs and carnivals in the 1960s and 1970s. His expanding body of work was eventually housed at his Tinkertown Museum, which, according to the museum's greeting sign, "was begun as a hobby in 1962" and is now a popular attraction on the Turquoise Trail. More than 20,000 visitors a year are captivated by the displays filled with Ward's carvings and animated dioramas. His hand-painted and hand-carved signs are still visible all along the Turquoise Trail. (Courtesy Carla Ward and the Turquoise Trail Association.)

ON THE COVER: Mount Chalchihuitl is the site of the oldest turquoise mine and the most extensive prehistoric mining activity in North America. Artifacts dating back to about 1000 AD, including large stone mauls and hammers used to mine turquoise, have been found at the site. The north side of the hill was completely quarried out by the Native Americans, who were still actively mining there when the Spanish began their own mining efforts in the area. The Spanish did not value turquoise and left it for the Indians to collect. (Courtesy Eldred Harrington Photographic Archives, Center for Southwest Research.)

IMAGES
of America

THE TURQUOISE TRAIL

Laurie Evans Frantz

ARCADIA
PUBLISHING

Published by Arcadia Publishing
Charleston, South Carolina

Printed in the United States of America

Library of Congress Control Number: 2013930177

For all general information, please contact Arcadia Publishing:
Telephone 843-853-2070
Fax 843-853-0044
E-mail sales@arcadiapublishing.com
For customer service and orders:
Toll-Free 1-888-313-2665

Visit us on the Internet at www.arcadiapublishing.com

This book is dedicated to my darling husband, Doug, who encouraged me every step of the way and provided technological expertise and an extra pair of hands when I needed them.

CONTENTS

ACKNOWLEDGMENTS

This would not have been a book without Lynn McLane and Carla Ward of the Turquoise Trail Association, who brought the project to my attention in the first place; Paul Secord, who gave me advice from his experience in putting together his own Arcadia Publishing book when I was still considering whether or not to take on the project; Patricia Brown and Bill Baxter, who provided the first photographs I used for the book proposal—photographs that turned into the Cerrillos chapter; and Bill Henderson, who invited me into his home and called upon his amazing memory to regale me with stories about a lifetime on the Turquoise Trail. Henderson provided almost all the information about Golden and a lot about Madrid, too. Henderson's daughter and son-in-law, Desiri and Allen Pielhau, helped organize the Golden material and read the entire book for accuracy.

I would also like to thank Nancy Tucker, who allowed me to peruse her postcard collection for images I could use in the book; Melinda Bon'ewell, who shared her huge collection of photographs and historical articles and information about Madrid; Mary Huber Duncan, who gave me permission to use her family photographs; Fred Friedman for inspiration; the staff at the Center for Southwest Research at the University of New Mexico, Albuquerque, especially Claire-Lise Benaud and Eileen Hogan, who guided me through the process of using the center's photographic archives; and, of course, Kristie Kelly, Jeff Ruetsche, Sara Miller, and Stacia Bannerman at Arcadia Publishing for their guidance throughout the project. Last but not least, my husband, Doug, provided the encouragement and help that enabled me to see the project through to the finish.

INTRODUCTION

The Turquoise Trail is the popular name for New Mexico State Route 14, the scenic route between Santa Fe and Albuquerque. A journey along the Turquoise Trail has often been called "the perfect day trip," and it is. But the story of the trail is much more complicated than it may appear to the casual traveler. The trail has been reinvented several times, and each time, it has a totally new character; it refuses to be relegated to memory.

The first mile of the trail is located east of Albuquerque in Tijeras. Going north, it runs 65 miles through the towns of Cedar Crest, Sandia Park, Edgewood, Golden, Madrid, and Cerrillos. Not visible from the car are the settlements that are now uninhabited: Tijeras Pueblo, San Marcos Pueblo, Pa'ako Pueblo, and San Pedro, and, a few miles off the trail, Waldo, Hagan, Carbonateville, Coyote, and Dolores. A branch of the trail on State Route 536 heads through the Sandia Mountains to the Sandia Peak Ski & Tramway and Sandia Crest.

The first residents to call this area home lived at the three pueblos—San Marcos, Tijeras, and Pa'ako. Pa'ako was first occupied between 1300 and 1425 AD and again in the late 1500s or early 1600s. San Marcos was one of the largest pueblos in the Southwest in the 15th and 16th centuries and the site of a Spanish mission church in the early 1600s. San Marcos and Pa'ako were inhabited until around 1680, well into the Spanish era. Tijeras was occupied from the early 1300s until about 1425.

The Native Americans mined turquoise from a large vein—visible on the ground at Mount Chalchihuitl near Cerrillos—and traded it across most of the United States and Mexico. Santo Domingo and Cochiti Indians are known to have mined Mount Chalchihuitl into the 1870s. The Native Americans also mined lead, which they used to make glaze for pottery.

The Spanish were not interested in turquoise. They were after precious minerals, preferably gold. Spanish prospectors had heard about minerals in the vicinity of Cerrillos and visited the area in 1581. In August 1680, most of the Pueblo Indians revolted against the Spanish and drove them down to what is now El Paso, Texas. Any records of Spanish mining activity before that time were burned during the Pueblo revolt.

Twelve years later, Don Diego de Vargas led a group of Spaniards back to Santa Fe in a bloodless reconquest. He appointed an *alcalde*, or "mayor," of the Real de los Cerrillos in 1694 or 1695, by which time silver was being mined in the area. Cerrillos is the oldest official mining community in the United States.

In 1828, placer gold (gold that has eroded out of host rock and is obtained by panning) was discovered at the Old Placers Mining District in Dolores, New Mexico, and the rush was on. Miners settled at the camps of El Real de San Francisco and Placer del Tuerto. El Real de San Francisco eventually became the town of Golden. Starting around 1930, the wildcatters first mined coal in the Madrid area. Gold was also found at San Pedro in the 1840s.

New Mexico became a United States territory in 1848, and Cerrillos, although it was considered the territorial capital, was passed over in favor of Santa Fe. The territorial period saw a new level

of mining activity in Cerrillos. In 1879, miners leaving Leadville, Colorado, for better working conditions moved to Cerrillos to work the mines there. More than 1,000 claims were staked. The Atchison, Topeka, & Santa Fe Railway Company (ATSF) laid rails to Cerrillos in 1880, and the town bloomed around the tracks; Cerrillos was incorporated in 1891.

By the 1880s, mining had played out in Golden and San Pedro, and most of their inhabitants had moved on, but Madrid was growing. In 1892, a railroad spur was constructed from the main ATSF line to Coal Gulch, which was later known as Madrid. By 1899, all coal production in the area was consolidated at Madrid. In 1904, Cerrillos declined while Madrid was flourishing. The Albuquerque and Cerrillos Coal Company took over the mines in 1906. A few years later, the company's owner, George Kaseman, hired Oscar Huber as mine superintendent.

Huber wanted Madrid to be different from other mining towns, which tended to be rough and mostly populated by men. In an unprecedented social experiment, he transformed Madrid into a company town, a family-oriented place where community cooperation engendered a high standard of living. Services, many of which were paid for via dues given to an employees' club, made life much more comfortable than in the average mining town. The town boasted amenities such as medical care, law enforcement, and company stores and housing. It had its own baseball team and organized a famous Christmas display every year, a far cry from the average mining town. Madrid produced coal in large quantities until World War II depleted the labor force, and the introduction of natural gas as a heat source diminished demand.

In 1958, a new industry began to capitalize on the Turquoise Trail: film. Walt Disney, who had visited the area for the first time around 1936, filmed parts of *The Nine Lives of Elfego Baca* in Cerrillos. In 1962, the television series *Empire* was shot at the Eaves Movie Ranch just north of Cerrillos. More than 60 movies have been filmed on the Turquoise Trail due to its unique character; in addition to the Eaves Movie Ranch, filmmakers have utilized Tijeras, Cedar Crest, Sandia Crest, Madrid, and Cerrillos.

Throughout the 20th century, the mining towns along the Turquoise Trail slowly drifted into oblivion. Area residents moved on to more profitable vocations and left the towns to bake in the sun and disintegrate. A few people stayed around, but Cerrillos, Madrid, and Golden became known as ghost towns. In the 1970s, people started to move back, many of them creative types trying to escape the trappings of civilization.

The modern towns of Cedar Crest, Sandia Park, and Edgewood—all at the south end of the trail—sprang up on the edge of the metropolitan Albuquerque area after the mining era. But the older towns of Golden, Madrid, and Cerrillos refused to die. They developed new identities as tourist towns with historical foundations. Old buildings were converted into shops and galleries. Dusty streets and historic buildings were marketed to film location managers. The Turquoise Trail now markets romance and excitement based on the toil and hardship of an earlier time.

One

CERRILLOS

Cerrillos is the site of the one of the oldest mines in the United States, and the Cerrillos Mining District is the oldest mining district in the country. Turquoise was being mined at Mount Chalchihuitl by Native Americans as early as 1000 AD. Native Americans also mined lead for use in pottery glazes. By 1150, they had established small mining camps in the area.

Spanish explorers knew of minerals in the area in the late 1500s. Spanish settlers mined at Cerrillos as early as 1694 and probably before 1680. *Cerrillos* means "little hills," and these little hills contained gold, silver, coal, and zinc, in addition to turquoise and lead. The Cerrillos Hills were claimed as part of a land grant between 1846 and 1869, but the US government rejected the claim in 1870, and the land became available for purchase.

In 1871, territorial delegate Steven Elkins purchased 606 acres of land in anticipation of the Atchison, Topeka, & Santa Fe Railway laying tracks through the area. Elkins chose land where he thought a townsite could be established, anticipating that he could make a fortune from subdividing and selling lots. The tracks arrived in Cerrillos in 1880.

In the meantime, two miners came down to Cerrillos from Leadville, Colorado, to try their luck. When they returned to Leadville, they spoke of gold, spurring a rush on Cerrillos, and 1,000 new claims were filed. A tent city sprang up, but tents eventually gave way to more permanent structures and the businesses necessary to support mining activities.

March 8, 1880— the day the railroad came to town and Los Cerrillos Station was established—is known as Founders Day in Cerrillos. The 1880s were the peak of Cerrillos mining activity. The early years of that decade saw the construction of Cerrillos' first hotel, first school, and second church. The mines started to play out by 1900, which signaled the start of the decline of Cerrillos.

Turquoise has been mined continually in the Cerrillos era since prehistoric times. Through the years, there have been 29 turquoise mining claims in the area, including one that supplied stones to Tiffany & Co. In the late 1880s, Tiffany & Co. deemed Cerrillos turquoise of the highest quality, and its price rose. The price declined in the late 1890s and has never again reached its 1880s level.

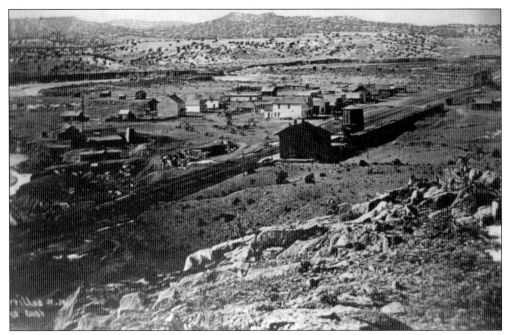

This photograph of Cerrillos dates to before 1890. The Atchison, Topeka & Santa Fe Railway (ATSF) built tracks through Cerrillos in 1880 as part of the route from Santa Fe to Albuquerque and San Marcial, where it connected with the Southern Pacific. Cerrillos was a major stop on the line because of the area's coal and water, and the ATSF built a depot there in 1882. The train transported coal mined from the nearby Cerrillos Coal Bank and took on water from the San Marcos Arroyo. In order to provide a reliable source of water that contained relatively low quantities of the minerals that clogged up the boilers of steam engines, the ATSF built a concrete dam on the arroyo a mile upstream from Cerrillos in April 1892. (Courtesy Patricia Brown.)

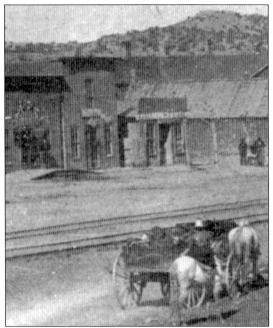

This 1890 photograph of Railroad Avenue in Cerrillos must have been taken before June 23, since a fire on that day destroyed the whole block (a total of 13 buildings). There were 21 saloons and four hotels in Cerrillos at the town's peak. This photograph represents one of the high points for Cerrillos' prosperity and population. William McKenzie's hardware store is on the left, and Doc Richards's drugstore is on the right at the corner of Second Street. Doc Richards's two-story residence is next to his drugstore. The pitched roof of the Milton Parmaly house, dating from late 1879 or early 1880 and reputedly the first private residence built in Cerrillos Station, is also visible. (Courtesy Patricia Brown.)

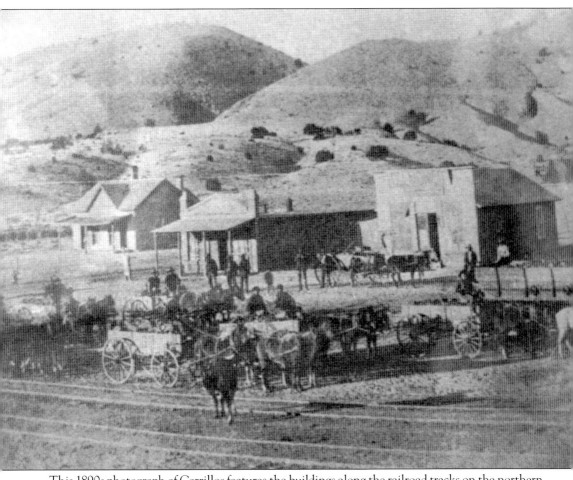

This 1890s photograph of Cerrillos features the buildings along the railroad tracks on the northern end of Railroad Avenue (now Santa Fe County Road 57), the road that leads to Waldo. In the 1890 election, Cerrillos had 340 eligible voters—adult males who had paid their poll tax. In 1890, the *Cerrillos Rustler* reported that there were no vacant houses in Cerrillos, also reporting that "Mrs. Utt, who has long been a demented woman of Cerrillos, was removed by the authorities to Santa Fe, this week." (Courtesy Patricia Brown.)

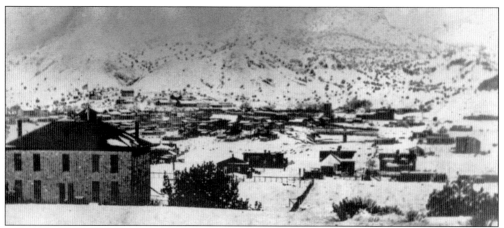

This winter view of Cerrillos shows the rear of Cerrillos Public School, the second school in town, which was built in 1892. This vantage point is from south of town. (Courtesy Patricia Brown and Andy Green.)

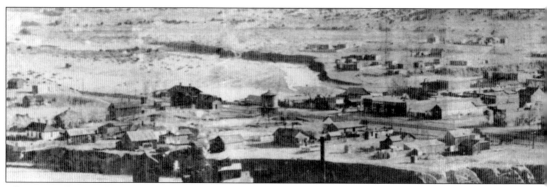

The original 1900 photograph of this panoramic view of Los Cerrillos is four feet wide. The ATSF depot is in the middle ground at left. The 1892 school is in the distant background, about a third of the way from the right side of the photograph; students had to cross the Galisteo River, which

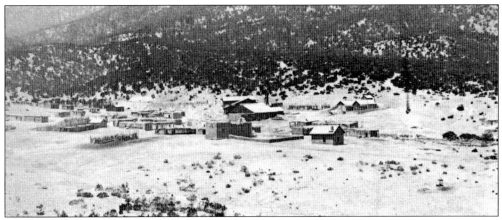

The town of Dolores, which was first known as Real de Dolores, is eight miles south of Cerrillos in the Ortiz Mountains. This c. 1880 photograph shows the Iglesia de Nuestra Señora de los Dolores (the building with the flat roof) in the center of the image; the priest's quarters are to the right. In the late 1820s, placer mining proved profitable in the area, and a gold-mining camp was established. At one time, 4,000 people lived here. The first stamp mill in the Rocky Mountains was constructed in Dolores in 1847. The almost-level cut in the hillside behind the buildings is the first railroad in New Mexico, which was one-and-one-third miles long and was built by the New Mexico Mining Company to move ore from the Old Ortiz Mine to the stamp mill; the railroad was in operation from 1867 until about 1871. (Courtesy Patricia Brown.)

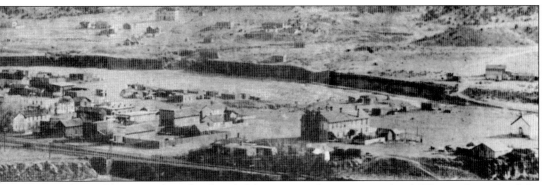

was located between the school and the town, on their way to school. The smokestack of the smelter is visible in the center foreground. (Courtesy Patricia Brown and Andy Green.)

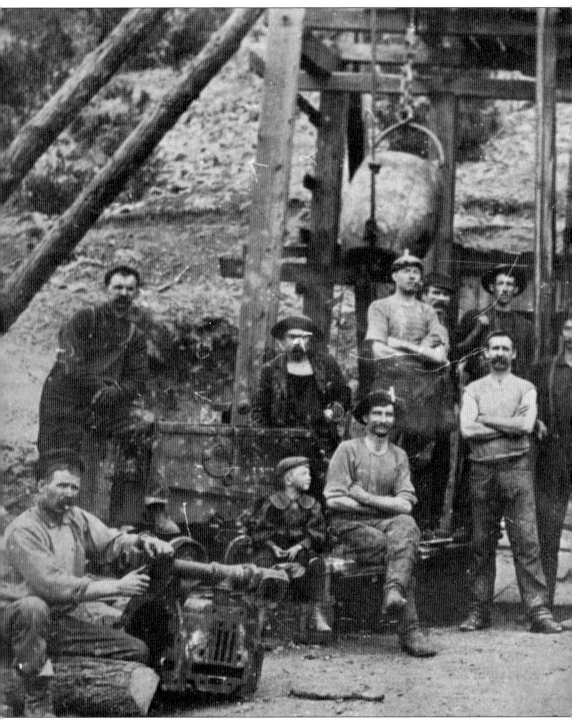

A group of unidentified men (and one small boy) pose in front of the Old Ortiz Mine near Dolores in 1880. The New Mexico Mining Company (NMMC) acquired the Ortiz Mine in 1864. In 1899, the NMMC leased the Ortiz Grant to the Galisteo Company for 99 years. The Galisteo Company contracted with Thomas Edison to design and build a dry placer plant to extract gold

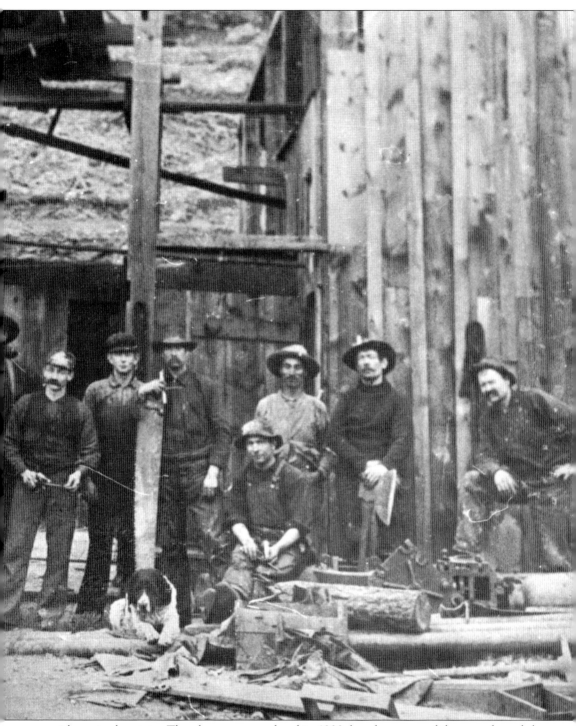

with static electricity. The plant was completed in 1900, but the process did not work, and the mill only operated for five months. (Courtesy Alice Bullock Photographic Archives, Center for Southwest Research.)

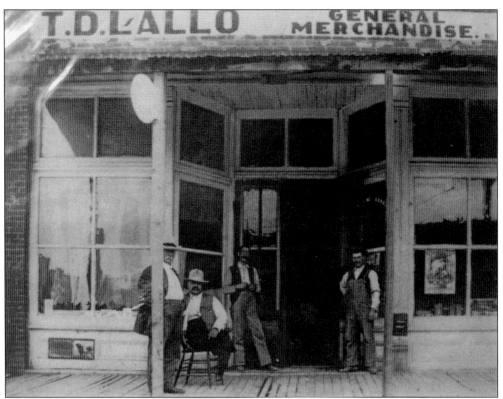

Tomas DeLallo owned this building for about thirty years, starting around 1900. It was first a saloon, but by 1909 it was the Cerrillos Mercantile Company, which grew to have branches in San Pedro and Waldo. (Courtesy Patricia Brown.)

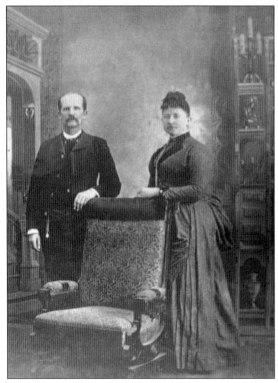

William C. and Maud Hurt of Cerrillos are pictured here in the 1880s. William had a stroke when he was 25. The Hurts settled in Cerrillos for his health in 1881 and invested heavily in area real estate. Hurt owned a general merchandise store in Cerrillos. In 1888, Hurt bought a large building on Main Street, known as Hurt's Hall or the Clear Light Opera House, which was used for dances, concerts, plays, and meetings. William died in 1889. (Courtesy Patricia Brown.)

This order from W.C. Hurt to the Browne and Manzanares wholesale warehouse in Las Vegas, New Mexico, is dated September 13, 1884. Browne and Manzanares opened many markets along ATSF train routes. This order would have come on the train from Las Vegas. The items Hurt ordered—salted meats, tobacco, and coffee—were staples for men working in the mines far from the amenities of town life. (Courtesy Patricia Brown.)

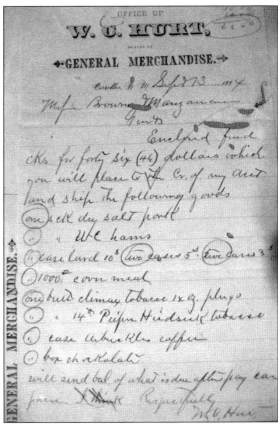

Harry C. Yontz stands in front of his Cerrillos jewelry store. Note the faint but still legible inscription over the windows that reads: "Mitchell & Jones Groceries." F.H. Mitchell and Frank M. Jones were business partners in Cerrillos from around 1895 to 1998. Yontz was a watchmaker and jeweler in Cerrillos from 1894 to 1899. Mitchell & Jones must have occupied the building first and then moved to another location—a subsequent inadequate paint job left a reminder of their previous tenancy. (Courtesy Patricia Brown.)

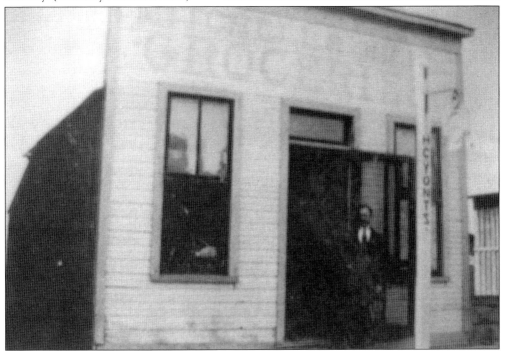

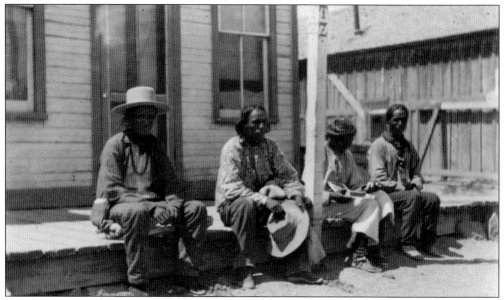

Cerrillos resident Harry C. Yontz is first known to have business interests in Cerrillos in 1894, when he owned a jewelry store. He placed advertisements in the *Cerrillos Register* between 1898 and 1900: "H.C. Yontz, Practical Watchmaker and Jeweler. Dealer in Watches, Clocks and Jewelry. Fine Turquoise a Specialty. I buy for cash and am prepared to sell at lowest prices. Gem setting neatly done." These four unidentified men likely sold Yontz some of their handiwork. Yontz had a brother in the jewelry business in Gallup, which is still a well-known location for buying Native American jewelry. In June 1901, Yontz moved to Santa Fe, where he continued in the jewelry business. His store there, which was located next to Santa Fe Book and Stationery, closed upon his death in 1936. He was buried at Fairview Cemetery in Santa Fe; his tombstone states that he was born in 1866. (Courtesy New Mexico Locales Collection, Center for Southwest Research.)

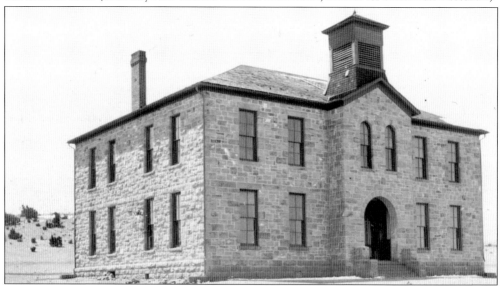

This photograph of the Cerrillos Public School probably dates from about September 1892, the first year it was in use. The school's principal teachers that year were John M. Barnhardt, who taught in English, and Flavio Silva, who taught in Spanish. (Courtesy Patricia Brown.)

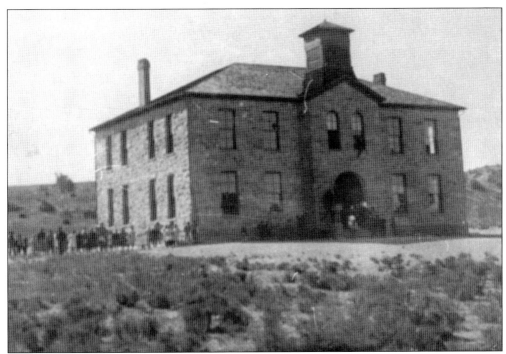

The school was built south of town in Otro Lado (meaning "other side") across the Galisteo River. Flash flooding along the river frequently wiped out the bridges built to span it, and the safety of students—who had to cross the river to get to school—was always a concern. The year after this photograph was taken, a cable-supported footbridge was built across the river from the south end of First Street to Otro Lado. It was dismantled in 1898 because of concerns over its safety. (Courtesy Alice Bullock Photographic Archives, Center for Southwest Research.)

Here, primary and intermediate students pose in front of the Cerrillos Public School. The class was taught by Fannie McNulty (back row, fourth from left). Fannie's father, James P. McNulty, was supervisor of the turquoise mines owned by the American Turquoise Company, which was associated with the famous New York jeweler Tiffany & Co. (Courtesy Patricia Brown.)

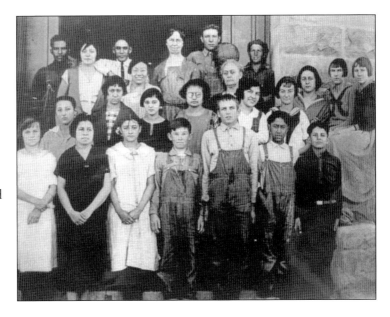

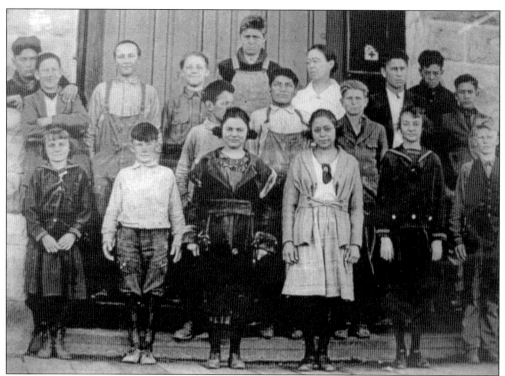

Cerrillos' first school was built on the north side of the railroad tracks in 1883. This class stands in front of the second school building around 1920. From 1929 until 1942, the second floor of this building housed Cerrillos High School. In 1962, the Cerrillos primary school was closed due to low enrollment. (Courtesy Patricia Brown.)

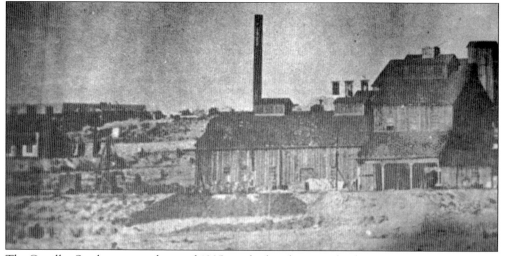

The Cerrillos Smelter, pictured around 1905, was built in late 1897 by the Mary Mining & Smelting Company; the smelter went broke within five years. Territorial delegate Stephen Elkins owned the land next to the San Marcos Arroyo on which the smelter—as well as the entire town of Cerrillos—sat. In 1871, Elkins bought 606 acres of land at the future site of Cerrillos at $2.50 per acre. He then formed the Cerrillos Land Company with attorney and politician Thomas Catron. (Courtesy Patricia Brown.)

Los Cerrillos Mining Company was incorporated in Phoenix, Arizona, on February 2, 1916. Its statutory agents were Celora Martin (C.M.) and M.L. Stoddard. C.M. Stoddard was the son of Isaac Taft Stoddard, who invested in Arizona mines. In 1901, Isaac Stoddard was appointed secretary of the Arizona Territory by Pres. Theodore Roosevelt. C.M. Stoddard was a member of the Arizona State Senate from 1921 until 1923 and ran for the Republican nomination for governor of Arizona in 1928 but lost. (Courtesy Patricia Brown.)

The Ortiz Gold King Mining company, incorporated in New Mexico, took its name from the Ortiz Mine Grant. In the early 1800s, Jose de Jesus Garcia and Rafael Alejo discovered gold in the Oso Mountains but didn't have the means to mine it. In September 1833, they sold their rights to Lt. Francisco Ortiz, commander of the Real de Dolores, and Ignacio Cano for 100 pesos. Ortiz and Cano worked the mine briefly before Cano sold his interest to Ortiz. The New Mexico Mining Company acquired the grant in 1858 and reopened the mine. (Courtesy Patricia Brown.)

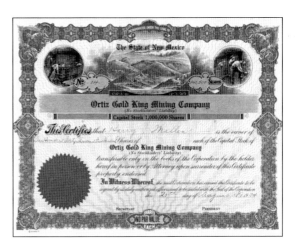

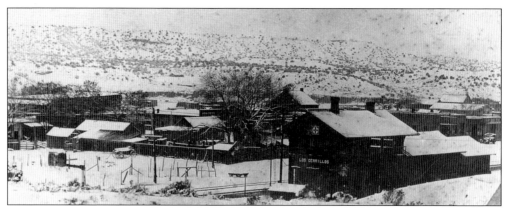

This c. 1930 winter view of Los Cerrillos shows the ATSF railroad depot in the right foreground. By this time, the only significant mining in the area was for coal. (Courtesy Patricia Brown and Andy Green.)

The Palace Hotel, located at the corner of Third and Main Streets, was built in 1888 by Richard Green and run by his wife, Mary; it offered Cerrillos' most upscale lodgings. The town doctor, dentist, and tailor all had offices in the hotel, and the Masonic lodge held their meetings there. Dr. Friend Palmer had treated notorious outlaw Black Jack Ketchum for a bullet wound in his second-floor office, and the bloodstain on the floor became a local tourist attraction. Ketchum became more notorious after his death, when a freak accident at his hanging in Clayton (located in the New Mexico Territory) caused him to be decapitated. Richard Green died at the Palace Hotel in 1906, and in 1911, Mary sold it to Joe and Anna Vergolio for $300 in gold. The hotel burned down on October 27, 1968. (Courtesy Alice Bullock Photographic Archives, Center for Southwest Research.)

Austin L. Kendall, notary public and justice of the peace, originally purchased this lot at Third and Main Streets in 1897 and built his home there. He sold it to Juanita de Olivas around 1902, who sold it to Edgar and Elizabeth Andrews in 1910. Edgar Andrews died soon after in a mining accident, and his wife turned their home into a boardinghouse for up to 40 miners. In the 30 years she kept the boardinghouse, her pies became so well known that passengers on the trains that stopped for water in Cerrillos would buy them. She also hosted several notable guests, including Thomas Edison. The adobe building still stands and is now home to Cerrillos Hills Bed and Breakfast. (Courtesy Patricia Brown.)

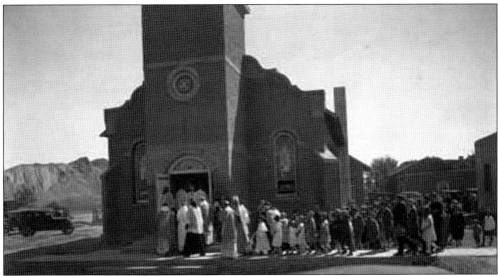

Mass is still celebrated at the St. Joseph Church in Cerrillos, which was completed in 1922 under the direction of master carpenter Frank Schmit. The age of the automobiles in this photograph suggests that it was taken soon after the completion of construction. This building replaced the first Iglesia San Jose, built around 1884, whose location next door is now the parking lot for St. Joseph. (Courtesy Patricia Brown.)

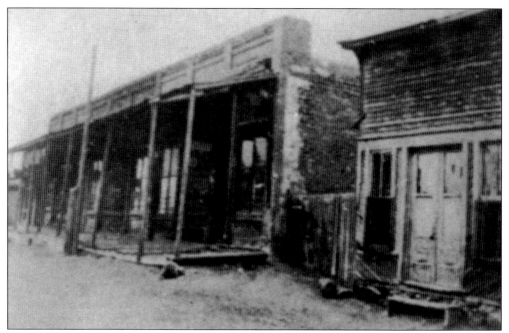

This Cerrillos street view is probably Main Street looking northwest. The dilapidated appearance of the buildings indicates that this photograph was taken after the town's disincorporation in 1904 and before its revival as a tourist town in the 1960s. (Courtesy Patricia Brown.)

George and Ida North bought this corner lot in 1889. They tore down the existing building, built a large adobe structure, and opened a furniture and hardware store. Later owners included Cipriano Lucero, Joe Juliano, Joe Zucal, Joe Coyle, and Warren Sands. In 1907, James Patrick McNulty bought three corner lots at this location on Main and First Streets. McNulty managed the American Turquoise Company's turquoise holdings, including the Tiffany mine, near Cerrillos. This photograph dates to sometime between 1962, when Fran Eckols and Nadine Heiden opened the Tiffany Saloon and Restaurant, and March 15, 1977, when the building burned down. (Courtesy Nancy Tucker.)

Walt Disney filmed the television series *The Nine Lives of Elfego Baca* in Cerrillos in 1958. Several episodes of the series were edited into the movie *Elfego Baca: Six Gun Law* in 1962. Robert Loggia (center) played the title role. Parts of the series were filmed in Cerrillos' Tiffany Saloon and Restaurant. Local lore says that Walt Disney first visited the area with his employee Walter Lantz in December 1936. Lantz's brother, Paul, worked for the Albuquerque and Cerrillos Coal Company in Madrid. (Courtesy Patricia Brown.)

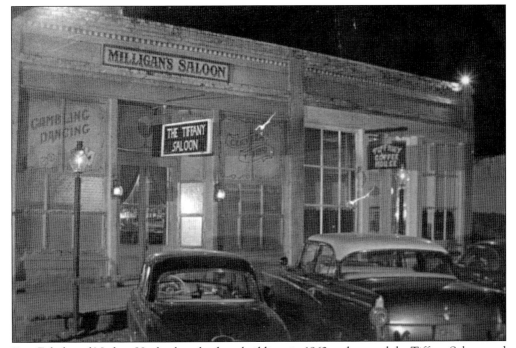

Fran Eckols and Nadine Heiden bought these buildings in 1962 and opened the Tiffany Saloon and Restaurant, later adding the "Melodrama Theater" to the existing businesses. Its namesake is the Tiffany & Co. jewelry company. Tiffany's bought the best turquoise from the mines on Turquoise Hill, which were owned by the American Turquoise Company in 1892. Until 1889, New Mexico turquoise was considered of low value, but Tiffany & Co. began to market Cerrillos turquoise as equal to and better than Persian stones. Subsequently, the value of New Mexico turquoise rose higher than that of gold within three years. (Courtesy Patricia Brown.)

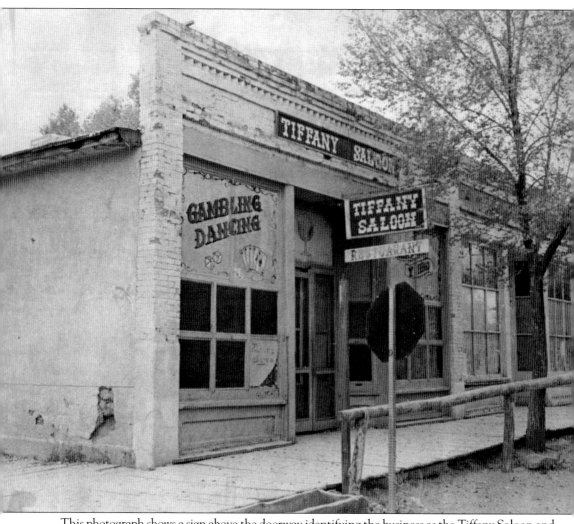

This photograph shows a sign above the doorway identifying the business as the Tiffany Saloon and Restaurant. (Courtesy Alice Bullock Photographic Archives, Center for Southwest Research.)

Two

MADRID

From the 1830s through the 1850s, wildcatters established camps at Coal Siding, later called Coal Gulch, to mine 30 square miles of coal, both bituminous and anthracite. In 1869, the town of Madrid (pronounced "MA-drid") was established. By 1892, the coal yield was large enough to enable the construction of a railroad spur connecting to the main line of the Atchison, Topeka & Santa Fe Railway. An anthracite breaker was constructed, and by 1899, all coal production in the area was consolidated at Madrid.

In 1919, the Albuquerque and Cerrillos Coal Company promoted Oscar Huber, who had worked for the company since 1910, as superintendent of mines. Mining towns were rough places that were mostly populated by men, and Huber wanted Madrid to be different. Frame houses were brought in on the train from a coal town in Kansas, and Madrid became a "company town." At its peak, it was inhabited by 2,500 to 3,000 people of many different ethnicities.

Madrid had its own schools, company store, hospital, employees' club, gas station, car dealership, Chinese laundry, and baseball team. It had medical and dental offices (with the first x-ray machine in New Mexico), a six-hole golf course, and tennis courts. Amenities included beauty parlors and barbershops, a hotel, an amusement hall, and a brass band. The town held celebrations at Easter and Fourth of July and set up a huge Christmas display.

Madrid had electricity early and was very technologically advanced for a town in the Southwest. Legend has it that the baseball field was the first one west of the Mississippi to be illuminated. The 150,000 lights of the Christmas display were illuminated by 500,000 kilowatt hours of electricity.

World War II and the decline of coal as a heat source contributed to Huber closing the mines in 1954. Miners left town abruptly, leaving dishes and furniture in their houses. Huber sold everything he could and listed the whole town in the *Wall Street Journal* for $250,000, but there were no takers. The remains of the mining operations are still evident, but Madrid's economy is now based on tourism. Its buildings have been renovated to house galleries and shops.

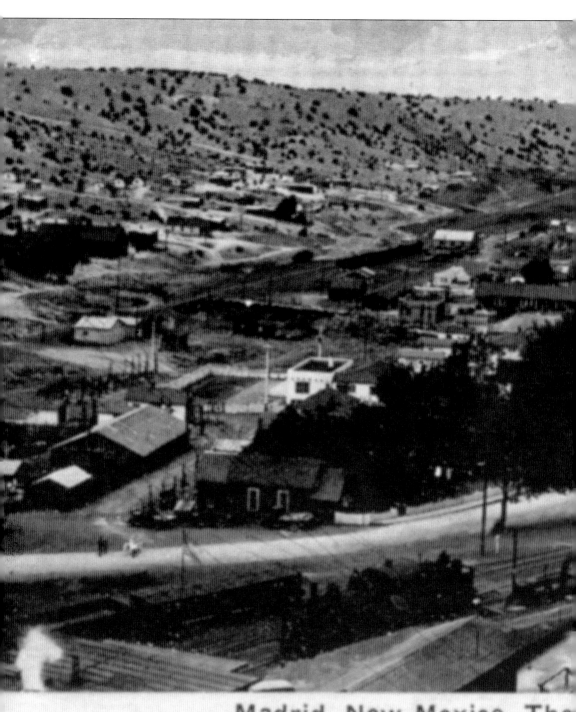

Madrid, New Mexico, The

Madrid is in the Ortiz Mountains at an elevation of 6,000 feet, 28 miles south of Santa Fe and 46 miles northeast of Albuquerque. It sits on a bed of high-grade anthracite and bituminous coal, a remarkable fact since anthracite and bituminous do not usually occur in the same place. Anthracite coal was first mined here in 1835 by wildcatters, and on a commercial scale in 1882.

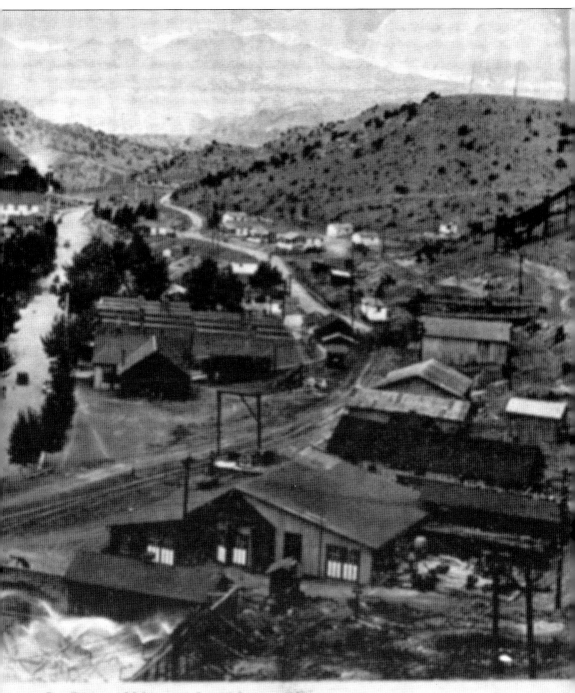

e of Cerrillos Anthracite

In this c. 1930 image, the steam engine sits on the tracks at the front left of the photograph. The ballpark is at the far end of town on the left side of the road. (Courtesy Albuquerque and Cerrillos Coal Company Photographic Archives, Center for Southwest Research.)

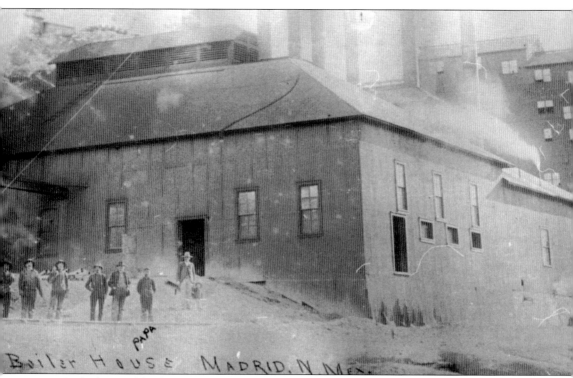

Boiler houses like this one used coal to furnish steam for the machinery, heat in the immediate neighborhood, the pumps inside the mines, and shaft engines. Commercial coal production began in the area in 1880, when the Atchison, Topeka & Santa Fe Railway reached Madrid. The Colorado Fuel & Iron Company of Pueblo, Colorado, leased the railroad's holdings in 1896 and ran them until 1906, when the mines were leased to George Kaseman, of the Albuquerque and Cerrillos Coal Company, who ran them until his death in 1938. This 1902 photograph was taken during the time that the Colorado Fuel & Iron Company ran the mines. (Courtesy Alice Bullock Photographic Archives, Center for Southwest Research.)

Oscar Huber had a profound influence on Madrid. George Kaseman, the president and manager of the Albuquerque and Cerrillos Coal Company, hired Huber as his secretary. Kaseman had problems with the mines and started sending Huber to straighten them out. Huber was promoted to superintendent of the Madrid mines in 1919 and held that position for about 20 years. When Kaseman was killed in a tragic accident at an oil well near Hobbs in June 1938, Huber bought the company from Kaseman's widow, Anna. (Courtesy Melinda Bon'ewell and Mary Huber Duncan.)

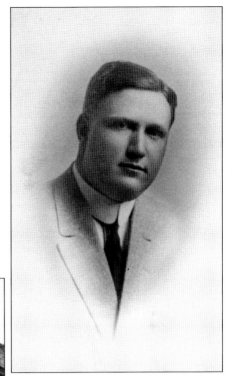

Pictured here in front of their house in Madrid are, from left to right, Joe, Oscar, Kathryn, and Mary Frances Huber. Huber moved his family to Madrid when he took the position of superintendent of mines in the early 1920s. In 1948, the Atchison, Topeka & Santa Fe Railway sold Huber the land and mineral rights, except for oil and gas. Huber and his family lived in Madrid until he closed the mines in 1954. (Courtesy Bill Henderson.)

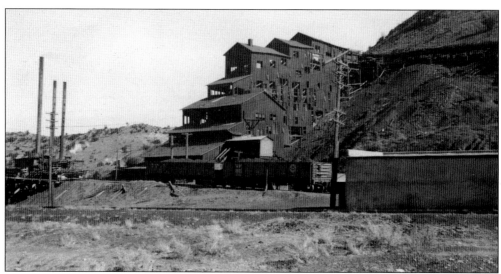

The power house for the Madrid mines is at left, and the anthracite coal breaker and tipple stretch several stories up the hill at right. The coal was broken into pieces and then sorted into uniform sizes. Impurities, such as slate, were removed from the coal and deposited in a dump. Coal breakers were always used—with or without a tipple—at anthracite mines. Coal was loaded into rail cars from the tipple. (Courtesy Eldred Harrington Photographic Archives, Center for Southwest Research.)

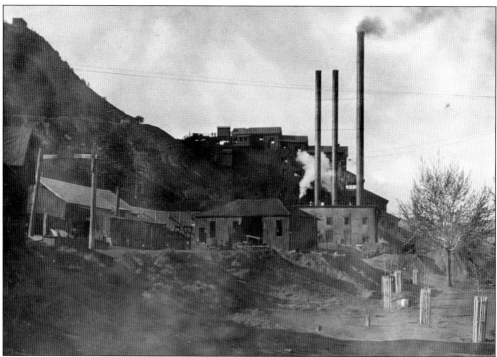

When Bill Henderson worked in the Madrid mines, Joe Collier took care of the breaker and Oren Pulliam took care of the soft tipple. Each of the mines had supervisors with separate and distinct responsibilities, and fire bosses were in charge of setting off detonations at night. (Courtesy Albuquerque and Cerrillos Coal Company Photographic Archives, Center for Southwest Research.)

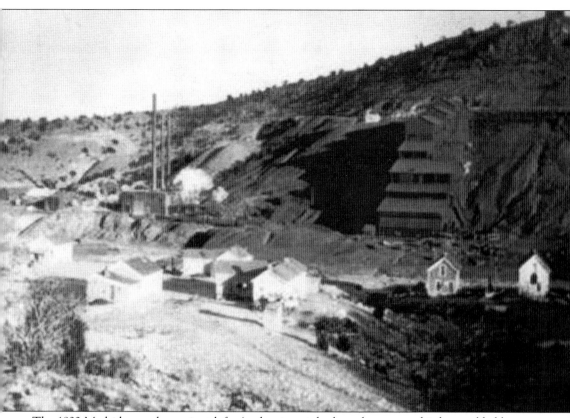

The 1922 Madrid powerhouse is at left. At the time, it had two burners; a third was added later. The hard coal (anthracite) breaker is the building running down the hill—this is where the workers crushed the coal into different sizes for sorting. (Courtesy Bill Henderson.)

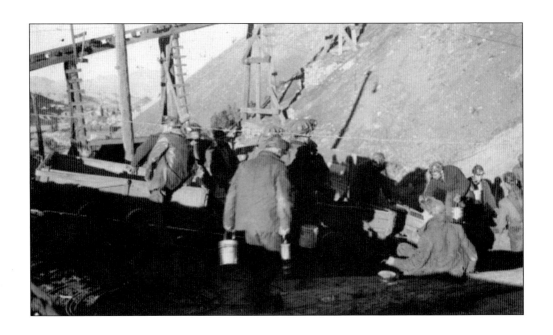

The miners pictured above are preparing to enter a mine. Below, miners McKnight and Beedle (the photograph contains no information about which man is which) are pictured at the Jones Mine portal. (Both courtesy Melinda Bon'ewell and Mary Huber Duncan.)

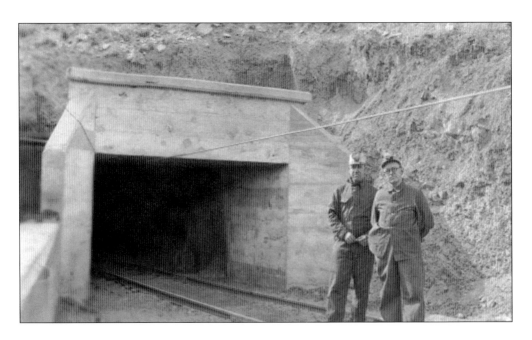

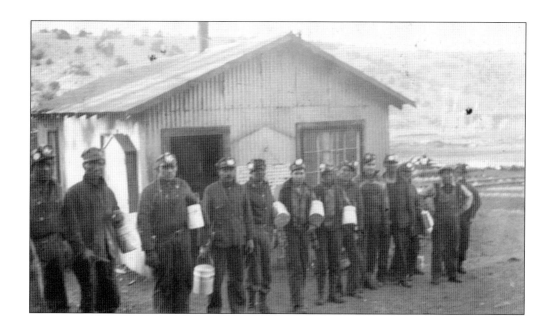

In the photograph above, miners at the foreman's cabin are getting ready to enter the No. 4 mine. Below, a full ore car sits on the tracks outside the portal to a Madrid mine. (Both courtesy Melinda Bon'ewell and Mary Huber Duncan.)

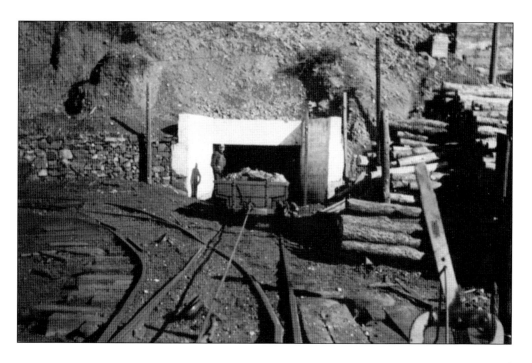

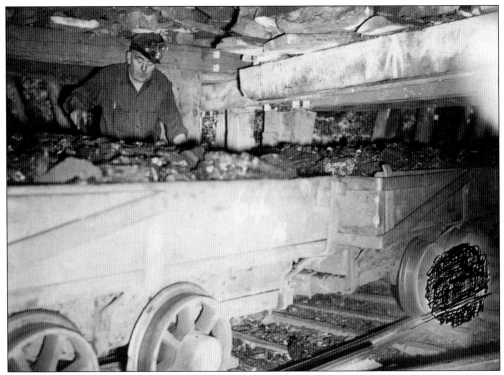

This photograph shows the heavy roof supports used to shore up the tunnel. The coal loaded into this ore car underground was sent to the breaker to be crushed into more uniform pieces. (Courtesy Eldred Harrington Photographic Archives, Center for Southwest Research.)

This is the sand shack where the company stored sand for the tramways at the soft coal tipple. The sand was screened and put on the tracks to keep the railroad engines' wheels from spinning. (Courtesy Bill Henderson.)

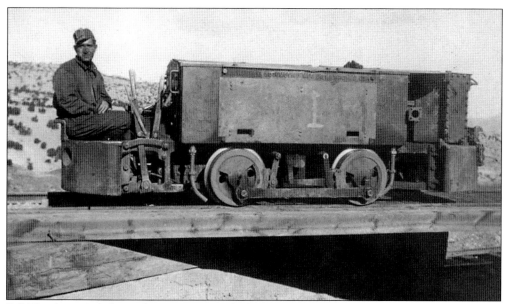

Bill Henderson's father, John, came to Madrid from Gallup in the 1920s after working for the railroad driving a produce delivery truck. George Kaseman owned a lot of stores on reservations around the state, and John Henderson got to know him. Kaseman had Henderson bring this little engine, or tram, to the Madrid mines and teach people to use it to pull the rail cars. Henderson ended up staying in Madrid and was hired as outside foreman of everything on the ground; he stayed until the mines closed. This car is now in the Madrid Old Coal Town Museum. (Courtesy Bill Henderson.)

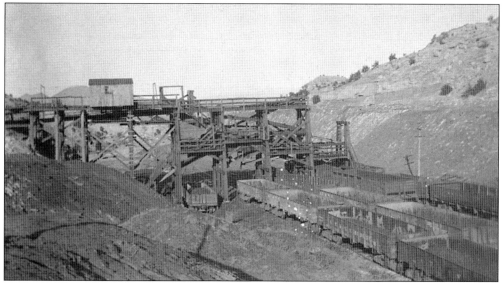

When Bill Henderson was at the Madrid mine, Oren Pulliam ran the soft coal tipple. The soft coal came out of the mine at different sizes and was processed here. It went through crushers and came out egg-sized, walnut-sized, and pea-sized. The different sizes were then separated and sold. The slag, or center section of the coal (they called it bone, but it was a form of unusable shale), was piled up south of the tipple and allowed to burn. The slack, or fine, coal was sold to the railroad shop. (Courtesy Bill Henderson.)

This Diamond T truck held from 10 to 12 tons of coal. These trucks hauled coal to schools and stores around the entire state. They also hauled coal to the Manhattan Project in Los Alamos in the 1940s and 1950s. When energy producers started switching to natural gas, there was no more need for the coal and deliveries stopped. (Courtesy Bill Henderson.)

These three Diamond T trucks are being loaded with coal for Los Alamos. Bill Henderson is on top of the first truck. Henderson had a 20-ton truck. The drivers were paid $1.18 per ton to drive coal to Los Alamos. (Courtesy Bill Henderson.)

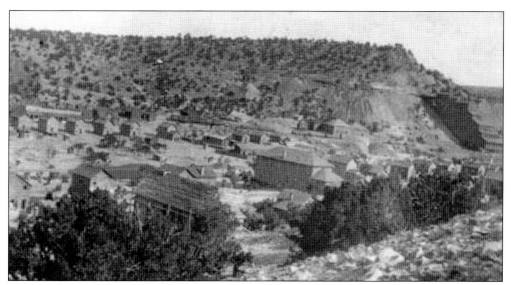

The Albuquerque and Cerrillos Coal Company offered services to employees and their families in the company town of Madrid. These included water, electricity, a post office, garbage collection, sidewalks, law enforcement, and a cemetery. Water was transported daily to Madrid from Waldo in railroad tanker cars. The company provided electricity, and all homes were wired by 1930. (Courtesy Bill Henderson.)

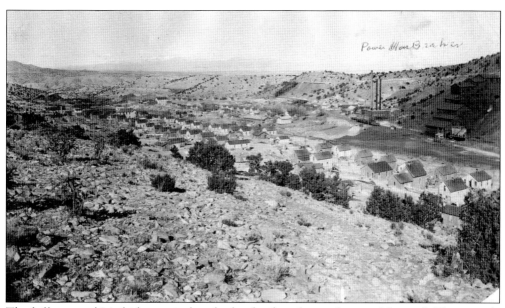

The hills around Madrid contain hundreds of miles of tunnels mined for coal. The tunnels slant downwards, and some reach a depth of as far as 1,000 feet below the surface. (Courtesy Bill Henderson.)

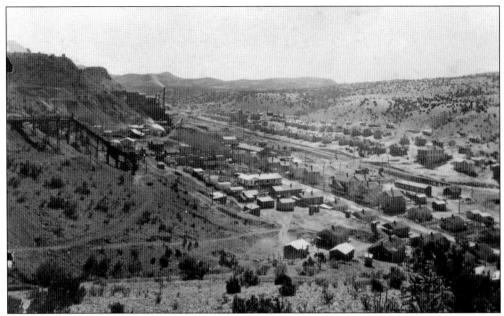

Before the Christmas lights put Madrid on the map, it was famous as the birthplace of Mae Marsh in 1894. Marsh's father was an auditor for the Atchison, Topeka & Santa Fe Railway, which meant that the family moved often. Marsh appeared in many films directed by D.W. Griffith, including a role as the little sister in *The Birth of a Nation* in 1915. (Courtesy Melinda Bon'ewell and Mary Huber Duncan.)

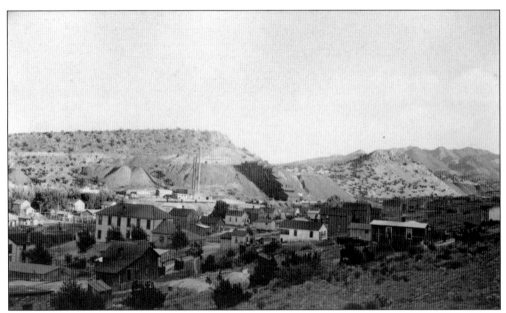

In 1930, Santa Fe County produced the third-highest amount of coal in New Mexico (after Colfax and McKinley Counties). The total production of coal in New Mexico in 1929 was 2,650,000 tons. The Albuquerque and Cerrillos Coal Company produced more than 300,000 tons annually. (Courtesy Melinda Bon'ewell and Mary Huber Duncan.)

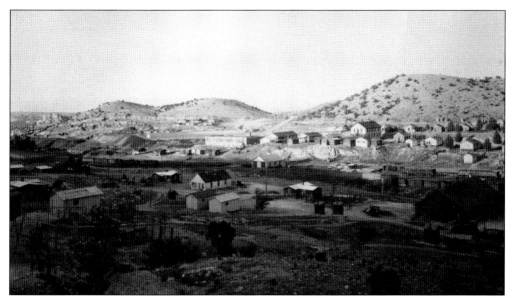

As with any mining town, Madrid experienced its share of accidents. Five explosions in the years between 1895 and 1932 took 55 lives. Unfortunately, because Madrid was a family town, many of the miners killed left families behind. (Courtesy Melinda Bon'ewell and Mary Huber Duncan.)

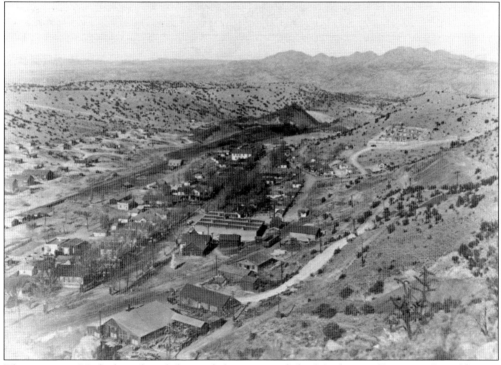

The mines at Madrid produced the coal that powered the Manhattan Project in Los Alamos. The atomic bomb invented in Los Alamos was detonated at the Trinity Site in the Jornada del Muerto valley, about 120 miles south of Madrid as the crow flies. According to John Husler (the son of Oscar Huber's accountant, Joe Husler), the miners could see the light from the explosion in Madrid. (Courtesy Melinda Bon'ewell and Mary Huber Duncan.)

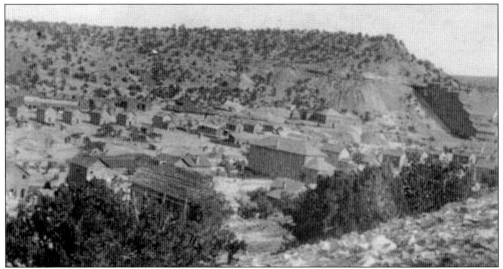

The identical miners' houses were cut into halves and brought in on the railroad. Many were from a coal mine in Kansas. Bill Henderson recalls that some of them were brought from a town near Raton. Raton sits in the Raton Basin, a source of bituminous coal. Some buildings that were too big to bring in, like the bunkhouse and the pool hall, were built on-site. (Courtesy Bill Henderson.)

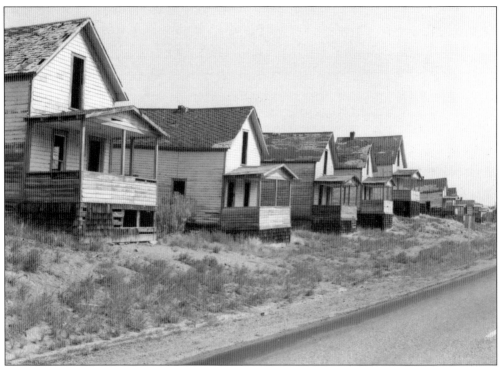

This photograph appears to be from after 1954, when the mines were shut down and the town was virtually abandoned. These homes look slightly dilapidated, but not nearly as bad as they became before people started to move back to Madrid in the early 1970s. (Courtesy Eldred Harrington Photographic Archives, Center for Southwest Research.)

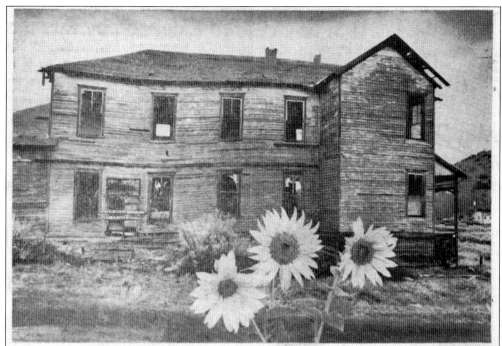

There are signs of life in the old town—sunflowers, which stand out in contrast to one of Madrid's battered buildings.

Times photos by John Malmin

Madrid: Where Nothing, Nobody Works

This 1976 *L.A. Times* article written by Charles Hillinger quotes one of Madrid's 150 residents as saying: "Nothing works in Madrid. Everything is broken down. The water system, the sewer system, everything." The problems were a result of 23 years of neglect and abandonment. (Courtesy Melinda Bon'ewell and Mary Huber Duncan.)

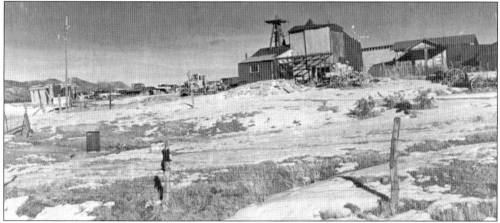

Oscar Huber sold whatever equipment he could before trying to sell the entire town. He put an advertisement in the *Wall Street Journal* on June 17, 1954, offering "200 houses, grade and high school, power house, general store, tavern, machine shop, mineral rights, 9000 acres, excellent climate, fine industrial location" for $250,000. No one bought it. (Courtesy Alice Bullock Photographic Archives, Center for Southwest Research.)

Oscar Huber negotiated to sell the mines to a Japanese company that was looking for coal for use in steel manufacturing, but the deal fell through. Huber died in 1962, leaving the property to his son Joe. (Courtesy Alice Bullock Photographic Archives, Center for Southwest Research.)

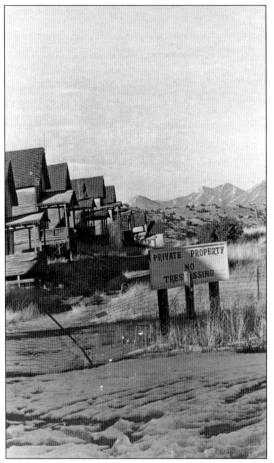

Joe Huber advertised the mines for sale, but the only person interested was Billie Sol Estes, who tried to purchase Madrid in 1964; negotiations fell through when Estes was imprisoned for fraud connected with a business scam. Huber then subdivided the town and began selling individual lots and buildings; he sold one house for $10. Finally, in 1975, he put all of the buildings up for sale, selling houses for $1,000 or $2,000 each and other buildings for a little more. (Courtesy Alice Bullock Photographic Archives, Center for Southwest Research.)

The image at right is an overview of Madrid. It shows the layout of the identical miners' houses that were brought in on the train. It also shows businesses, all of which were owned by the Albuquerque and Cerrillos Coal Company. (Courtesy Melinda Bon'ewell and Mary Huber Duncan.)

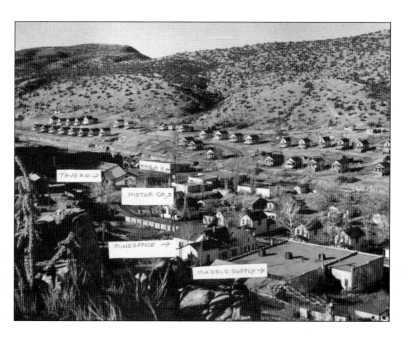

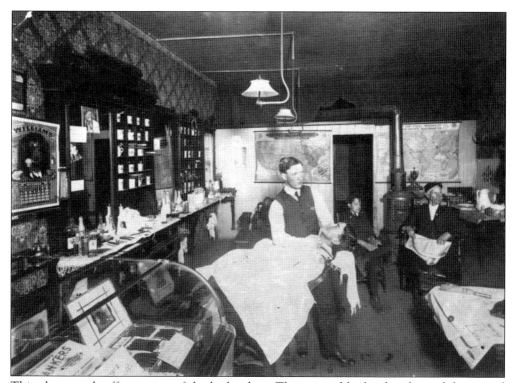

This photograph offers a view of the barbershop. The original barbershop burned down, and the new barbershop was built in the house next to the Huber family's home. A beauty shop was located next door to the Madrid Supply Company. (Courtesy Melinda Bon'ewell and Mary Huber Duncan.)

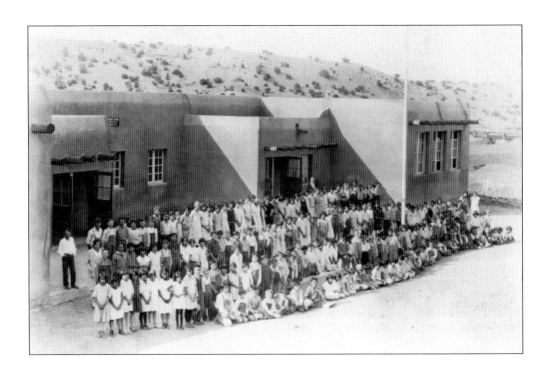

The image above was taken in the fall of 1929 at the Madrid Public School, which taught students from kindergarten through the eighth grade. The WPA later built a high school in Madrid. The photograph below shows Mrs. Hornsby's class in 1946. (Both courtesy Melinda Bon'ewell and Mary Huber Duncan.)

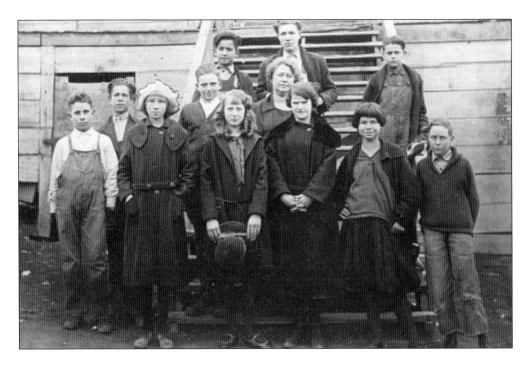

The Class of 1934

Huber,
Arris, Billy
Lucero, Mosa
Pappas, Jerry
Roybal, Ruben
Tabachi, Elsie
Pallares, Velia
Kuhnz, Virginia
Dunsworth, Ernest
Montoya, Elizabeth
Gurule, Nicolacita

MOTTO - Here Endeth - Here Beginneth.

COLORS - Pink and White

FLOWER - Rose

CLOSING EXERCISES

Madrid Public School

May 17 - 18, 1934

Note the variety of ethnicities reflected in the names listed in this commencement brochure for the 1934 Madrid Public School class. Miners came from all over the world to work in mines on the Turquoise Trail, and their jobs were often based on talents developed in their native countries. (Both courtesy Melinda Bon'ewell and Mary Huber Duncan.)

GRADE SCHOOL

Thursday Night, May 17, 1934
8:00 P. M.

THE OLD WOMAN WHO LIVED IN THE SHOE
Low First Grade

SONGS
High First Grade

THREE LITTLE KITTENS
Low First Grade

MUSIC FROM MANY COUNTRIES
Second Grades

BIRDS' CONCERT
Third Grade

WAND DRILL
Fourth Grade

ARKANSAS BARN DANCE
Fifth and Sixth Grades

COMMENCEMENT

Friday Night, May 18, 1934
8:00 P. M.

PLAY - - - - "FATHER'S DAY IN"
Graduating Class

CLASS PROPHECY
Nicolacita Gurule, Mosa Lucero
and Seventh Grade.

ADDRESS TO THE GRADUATES
Manuel Lujan, County Superintendent

PRESENTATION OF DIPLOMAS
R. L. Ormsbee, County Board of Education

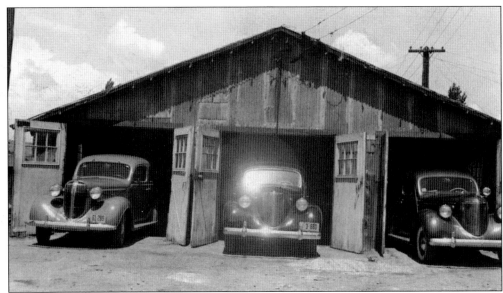

Oscar Huber started an automobile dealership and gas station in Madrid. This photograph shows the dealership in 1937. Huber was always interested in the latest inventions, and through the Western Finance Company, the miners could purchase cars on credit, which got Madrid residents interested in cars early in the history of automobiles. Locals started an automobile club with a goal of improving the roads. Madrid resident and historical researcher Melinda Bon'ewell said that at one time, Madrid had more cars per capita than any other place in the country. (Courtesy Albuquerque and Cerrillos Coal Company Photographic Collection, Center for Southwest Research.)

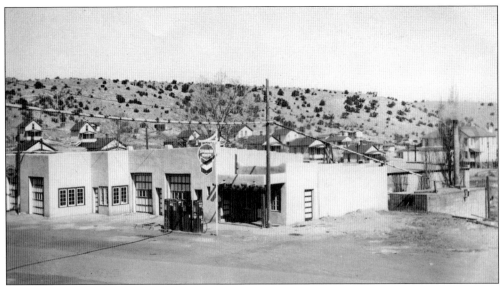

After World War II, the Huber Motor Company (shown here in 1946), garage, and gas station were combined and owned by Joe Huber, Oscar's son. He sold Chevron gasoline and had a Chrysler Plymouth dealership. (Courtesy Albuquerque and Cerrillos Coal Company Photographic Collection, Center for Southwest Research.)

The Lamb Hotel (the one-story building in the above photograph) was named for one of the Madrid engineers and replaced an earlier hotel that had burned down. After World War II, Oscar Huber started construction on a motel next to the hotel, but he halted construction when he realized that the coal market was collapsing. (Courtesy Albuquerque and Cerrillos Coal Company Photographic Collection, Center for Southwest Research.)

The Lamb Hotel was located at 2867 Highway 14 and was operated by Mr. and Mrs. Dale Darling, who are pictured on the right in the photograph at left (along with two unidentified employees) during Christmas in 1930. The image below shows the interior of the kitchen in 1935. (Both courtesy Melinda Bon'ewell and Mary Huber Duncan.)

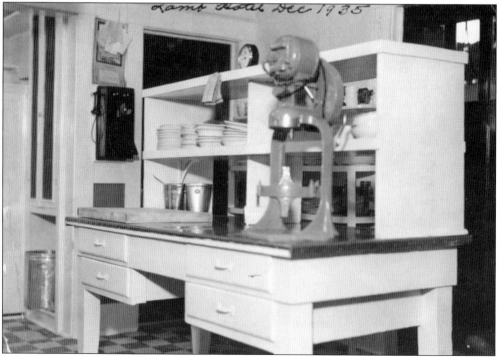

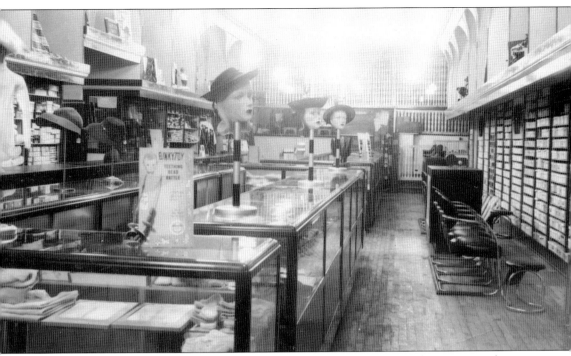

The Madrid Clothing Store sold a variety of items ranging from toy rattles to Stetson hats to shoes. All purchases were paid for by company scrip, a credit system in which the cost of the item was deducted from the miner's wages. (Courtesy Albuquerque and Cerrillos Coal Company Photographic Collection, Center for Southwest Research.)

62. The Colorado Supply Co.'s Store No. 19, Madrid, N. M.
(Now operated by the Madrid Supply Co.)

Madrid was a self-contained company town with everything the townspeople needed at hand. The amusement hall held dances and had a movie theater. The Madrid Supply Company (above) consisted of a grocery store (below), drugstore, clothing store, and an appliance and furniture store; it was managed by Charles Gibbs in the 1930s and 1940s. (Both courtesy Melinda Bon'ewell and Mary Huber Duncan.)

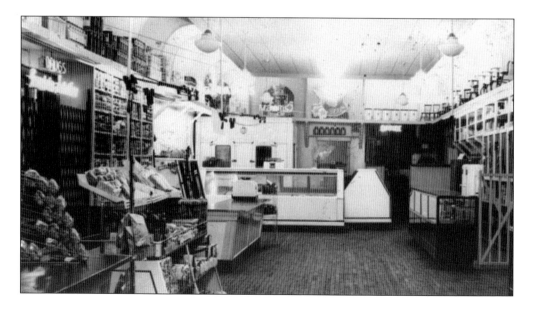

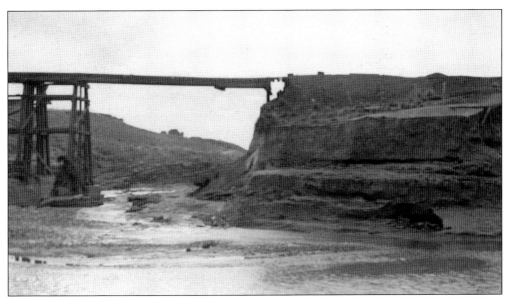

The Madrid gulch flooded the town in 1925. Bill Henderson remembers his father John talking about the "three-day storms" that would pull up moisture from the Gulf of Mexico, roll across Texas, and then "rain like hell" over New Mexico. One such storm caused this flood. Damage is visible on the right side of the bridge. (Courtesy Albuquerque and Cerrillos Coal Company Photographic Collection, Center for Southwest Research.)

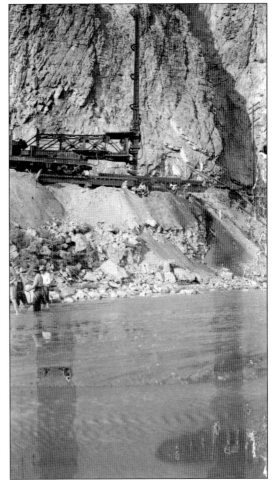

Floods are not common in New Mexico, but dry arroyos or gulches like the Madrid gulch can turn into raging torrents in a flash. (Courtesy Albuquerque and Cerrillos Coal Company Photographic Collection, Center for Southwest Research.)

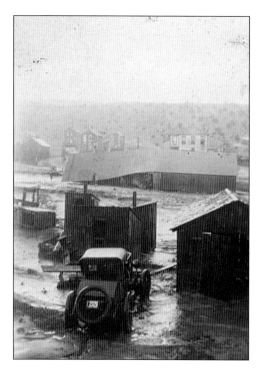

Water was scarce in Madrid and was hauled in on the train in tanker cars on the weekends. It is ironic that such a rare commodity caused so much damage. (Both courtesy Bill Henderson.)

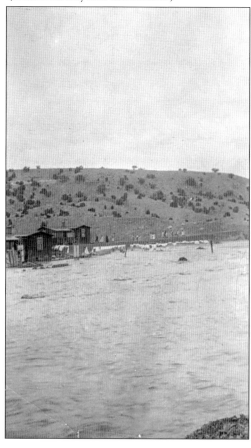

The flood caused a great deal of damage to the mines. The kids played on swamped equipment, and the roofs of several buildings collapsed. The photograph below shows flood damage in 1925. (Both courtesy Melinda Bon'ewell and Mary Huber Duncan.)

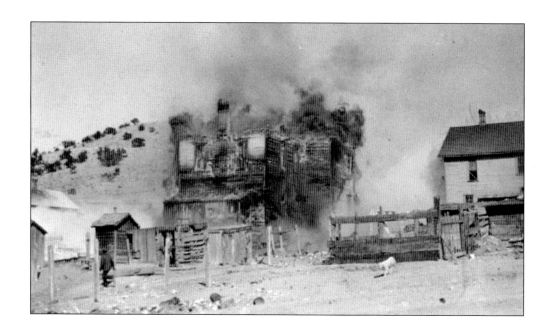

The image above shows an unidentified hotel burning; it was replaced with the Lamb Hotel. The photograph below shows a building being dynamited to put a fire out. Since water was scarce and dynamite was plentiful in Madrid, dynamite was detonated in order to suck up the oxygen that fed the flames. (Both courtesy Melinda Bon'ewell and Mary Huber Duncan.)

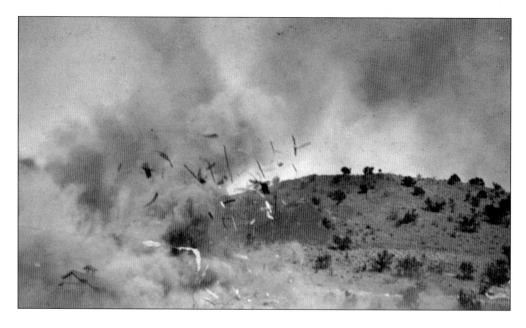

This late-1920s fire burned five homes on Front Street, including those of Bill Henderson's parents and grandparents. According to Henderson, plumbing had just been put into the houses on Front Street, but the pipes froze, and "Dad" Gibbs was thawing pipes with blowtorches. Someone asked Gibbs in for coffee, so he left the blowtorches burning underneath the house. One of them fell over and started the fire that burned down the block. (Both courtesy Bill Henderson.)

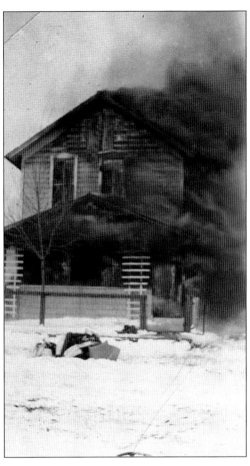

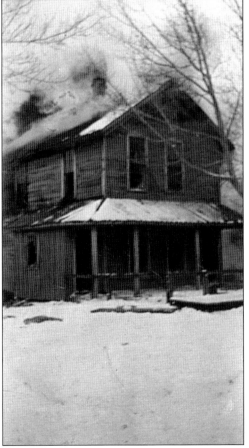

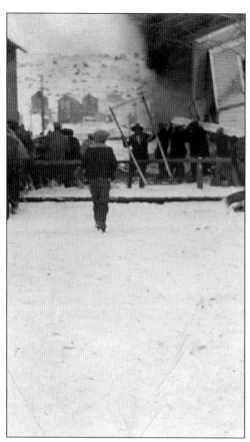

If a house close to the railroad tracks caught fire, Madrid's menfolk would put a cable around the house and attach it to the steam engine. The engine would then move down the track, stretching the cable and collapsing the house in an effort to keep the fire from spreading. They used the drinking water in the rail tanks to wet down buildings so they would not burn. (Both courtesy Bill Henderson.)

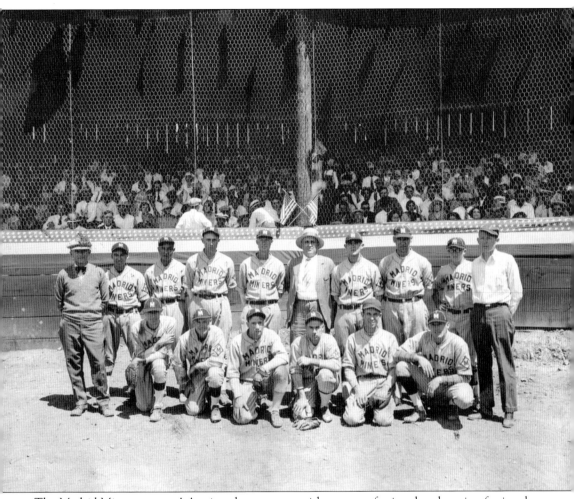

The Madrid Miners were a AA minor-league team with some professional and semiprofessional players. The whole town turned out for the team's home games. Their star was pitcher Emmett Jerome "Chief" Bowles, a member of the Potowatomi tribe from Oklahoma and a miner. He had pitched one inning for the Chicago White Sox prior to coming to Madrid but did not make it in the big leagues. All the players on this team were miners, but they were not allowed to work underground. Bowles was given special privileges because he was the pitcher. The Madrid Miners joined the Central New Mexico League in 1928. (Courtesy Bill Henderson.)

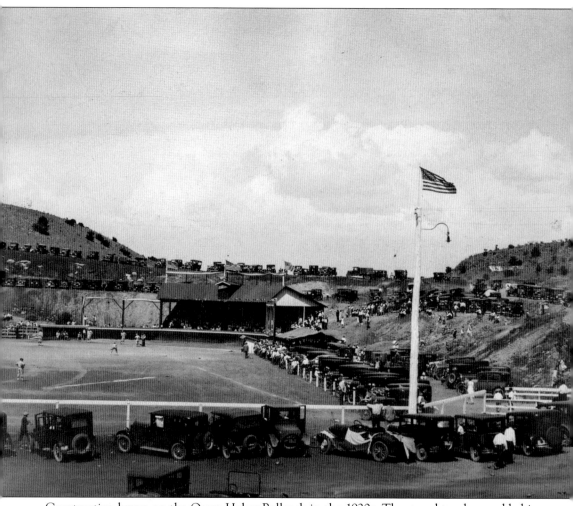

Construction began on the Oscar Huber Ballpark in the 1920s. The grandstand was added in 1928. "Dad" Gibbs ran the area's WPA group in the 1930s and cut all the stone for the ballpark and for the Madrid Public School. Almost everyone in Madrid owned a car, and they would park around the field and watch the game from their vehicles. When the Madrid Miners made a hit or scored a run, everyone would honk their horns. (Courtesy Bill Henderson.)

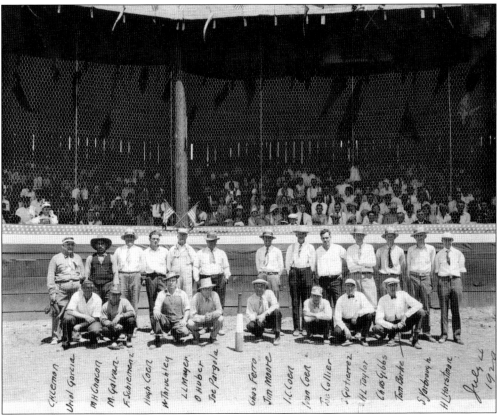

The Fats and Leans baseball team added to the fun on the Fourth of July in 1929. A baseball game was always part of Madrid's Fourth of July festivities. Oscar Huber is fourth from left and squatting in the front row. (Courtesy Melinda Bon'ewell and Mary Huber Duncan.)

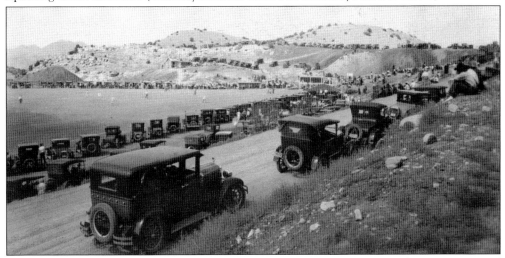

The Madrid ballpark may have been the first lighted ballpark in the country. The games attracted not only the townsfolk but also other visitors, sometimes doubling the size of the town during games. The Madrid Miners played teams from other New Mexico towns, and the players received bonuses after winning seasons. (Courtesy Melinda Bon'ewell and Mary Huber Duncan.)

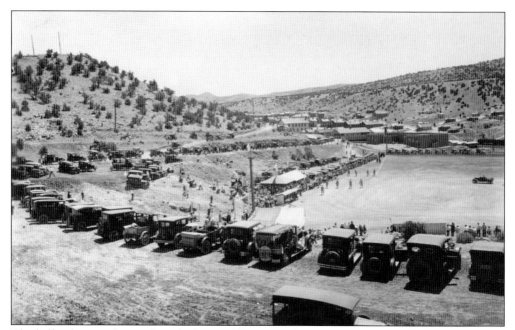

The ballpark is on the north end of town. If a person drove into town from the south end on a game day, they might have assumed that the town was deserted. (Courtesy Melinda Bon'ewell and Mary Huber Duncan.)

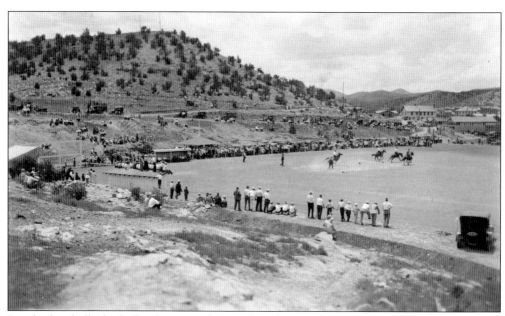

Besides baseball, the ballpark was used for rodeos (pictured), Native American dances, fancy riding on the Fourth of July, and the Christmas Toyland display. (Courtesy Melinda Bon'ewell and Mary Huber Duncan.)

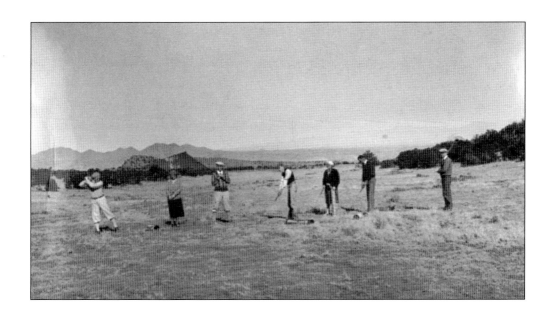

Oscar Huber believed the inhabitants of Madrid should keep busy, and there was always something going on, as shown in these photographs. An annual Easter egg hunt was held at the golf course. Women would dye eggs, which were hidden along with gold eggs that were worth $1. The Easter egg hunt is one of the few celebrations that continued after World War II. At one time, the town had a basketball court, tennis courts, a golf course, a playground, and a movie theater. (Both courtesy Melinda Bon'ewell and Mary Huber Duncan.)

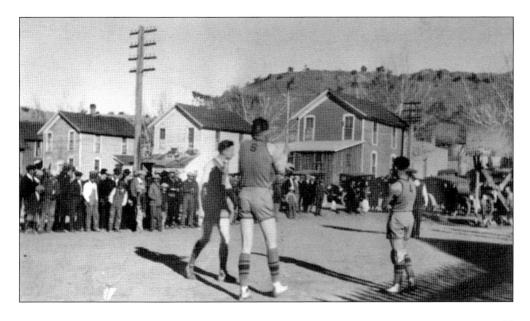

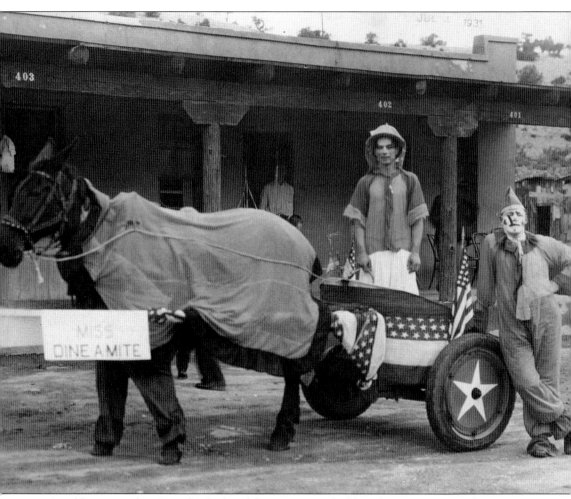

An old program for a Fourth of July celebration in Madrid lists famous Mexican clown Tony F. Cruz, aka El Carapintas, as a performer. Perhaps he is one of the unidentified people pictured above. Other Fourth of July activities in Madrid included a tug of war between the Slavs and Italians; Kay Shaffer, rodeo performer; daylight fireworks; a Taos Indian hoop dance; the Santa Fe Spanish Serenaders band; two baseball games; boxing and wrestling bouts; music by the Santa Fe Conquistadores brass band; and fireworks all evening. A street dance followed the fireworks. (Courtesy Albuquerque and Cerrillos Coal Company Photographic Collection, Center for Southwest Research.)

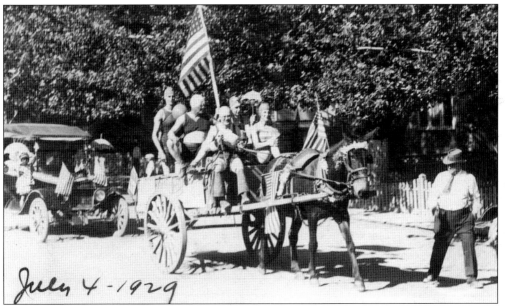

Jimmie Conrad's bathing beauties spiced up the Fourth of July parade in 1929. (Courtesy Albuquerque and Cerrillos Coal Company Photographic Collection, Center for Southwest Research.)

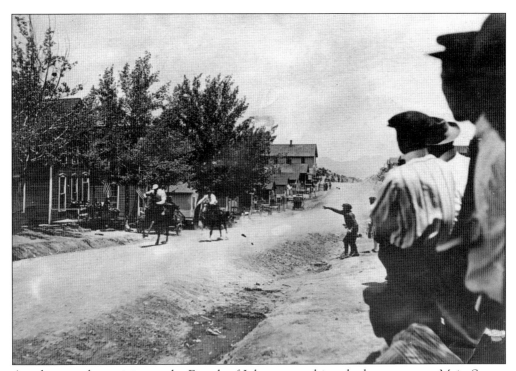

Another popular activity on the Fourth of July was watching the horse race on Main Street. This one took place in 1922. The town also held automobile races. (Courtesy Albuquerque and Cerrillos Coal Company Photographic Collection, Center for Southwest Research.)

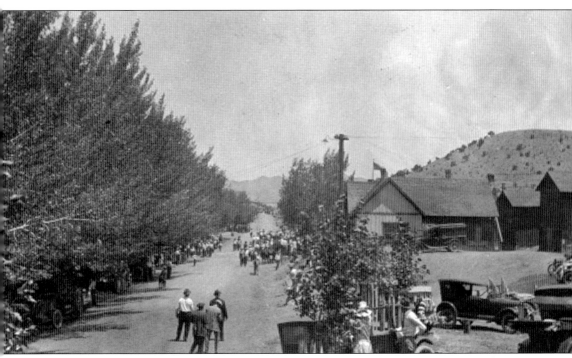

A brass band led the parade, which was well attended, as evident in street scenes from 1921 through 1926. Cars were always a big part of a Madrid parade, and there was a competition for the best decorated. One car ended up in a ditch during the automobile race in 1921. (Both courtesy Melinda Bon'ewell and Mary Huber Duncan.)

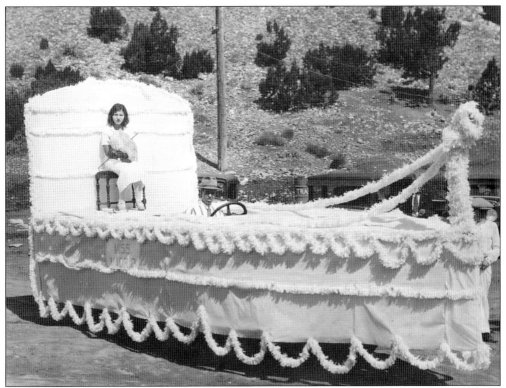

The unidentified young lady on the float was chosen as Miss Madrid. (Courtesy Albuquerque and Cerrillos Coal Company Photographic Collection, Center for Southwest Research.)

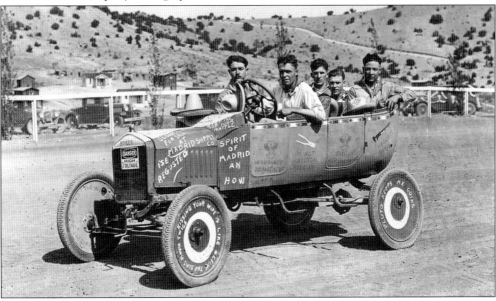

This is the bucking Ford. The faster it went, the higher it jumped. Anyone who got married in Madrid got a ride in it. Joe Collier, who ran the hard coal breaker, is behind the wheel; the other men in the car are unidentified. The car was decorated with various colors and designs for different occasions. (Courtesy Bill Henderson.)

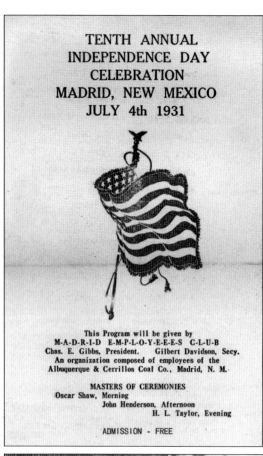

TENTH ANNUAL
INDEPENDENCE DAY
CELEBRATION
MADRID, NEW MEXICO
JULY 4th 1931

This Program will be given by
M-A-D-R-I-D E-M-P-L-O-Y-E-E-S C-L-U-B
Chas. E. Gibbs, President. Gilbert Davidson, Secy.
An organization composed of employees of the
Albuquerque & Cerrillos Coal Co., Madrid, N. M.

MASTERS OF CEREMONIES
Oscar Shaw, Morning
John Henderson, Afternoon
H. L. Taylor, Evening

ADMISSION - FREE

The Employees' Club was funded by monthly contributions from the Albuquerque and Cerrillos Coal Company employees. The coal company augmented their dues of 75¢ per month. In addition to the Fourth of July celebration, the club sponsored the baseball team, an Easter egg hunt, and the town's annual Christmas display. (Courtesy Melinda Bon'ewell and Mary Huber Duncan.)

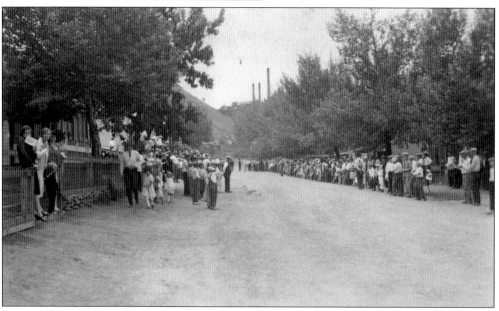

These folks are waiting for the Fourth of July parade to start in 1931. The whole town turned out for the parade. (Courtesy Melinda Bon'ewell and Mary Huber Duncan.)

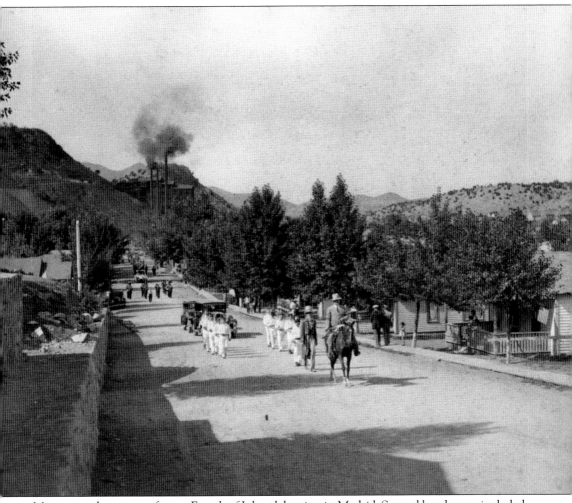

Music was a large part of every Fourth of July celebration in Madrid. Several bands were included, and Madrid residents performed musical selections solo or in duos. A program from one such celebration reports that a patriotic concert at the ballpark was to include "wonderful scenic effects of virgin forests, typical adobe ranch house and round up chuck wagon scenes, augmented by colored lighting." (Courtesy Melinda Bon'ewell and Mary Huber Duncan.)

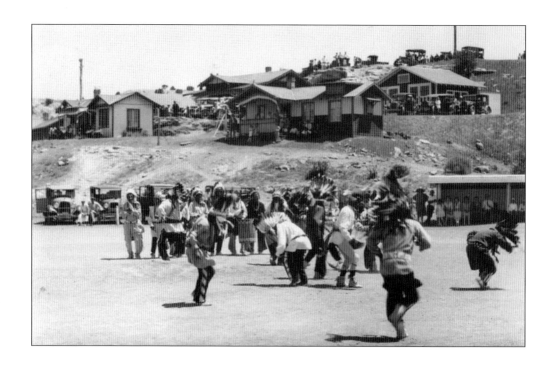

The Fourth of July celebrations included cowboys and Indians. Dancers from Taos Pueblo performed at the Oscar Huber Ballpark in 1929, and the other offerings often included trick riding, fancy riding, clown riding, and bronco busting. The neighborhood behind the ballpark was known as Hollywood. (Both courtesy Melinda Bon'ewell and Mary Huber Duncan.)

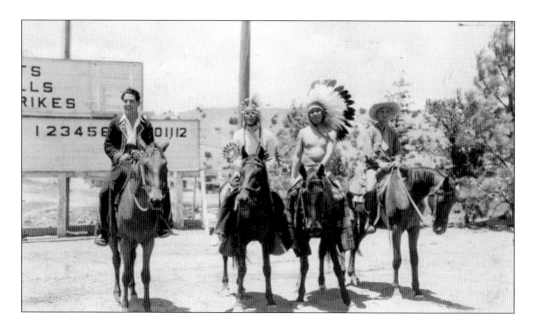

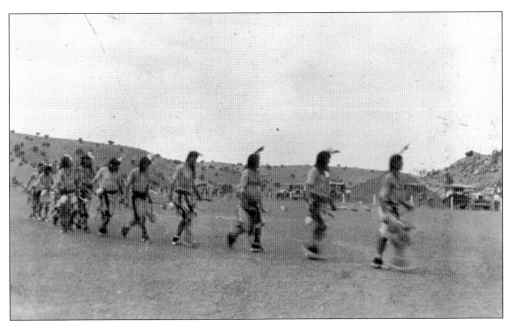

Native Americans participated in every Fourth of July parade in Madrid, including the one pictured above in 1931. (Courtesy Melinda Bon'ewell and Mary Huber Duncan.)

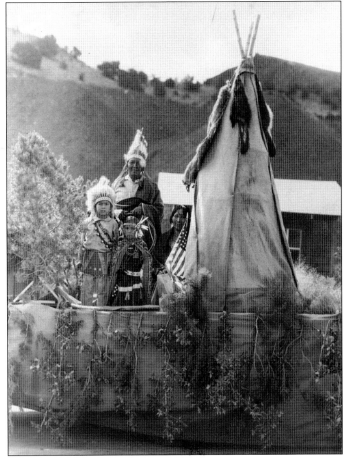

This 1931 Fourth of July parade float is accompanied by a group of dancers and musicians. Native American dancers often performed at the ballpark during July Fourth celebrations. (Courtesy Albuquerque and Cerrillos Coal Company Photographic Collection, Center for Southwest Research.)

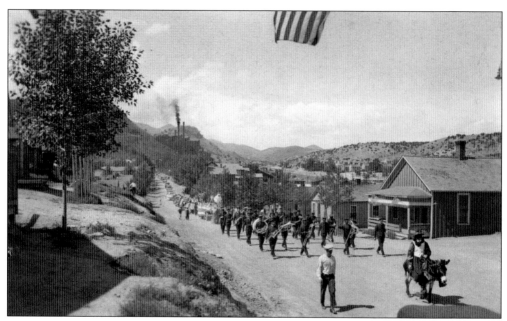

Every parade needs a brass band leading it, as shown in this photograph of the 1924 Fourth of July parade. As a program stated, "something doing every minute until noon." (Courtesy Melinda Bon'ewell and Mary Huber Duncan.)

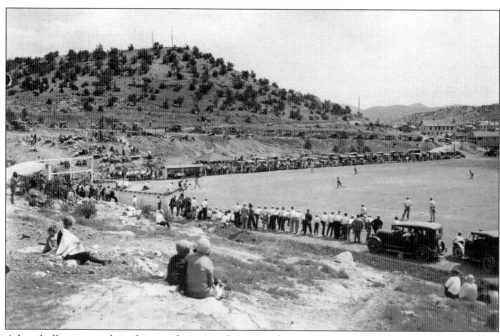

A baseball game, such as the one shown in this 1924 photograph, was also an essential part of any Fourth of July celebration. In 1929, the Santa Fe Saints played the Sport Shop, and the Albuquerque Dukes played the Madrid Miners. (Courtesy Melinda Bon'ewell and Mary Huber Duncan.)

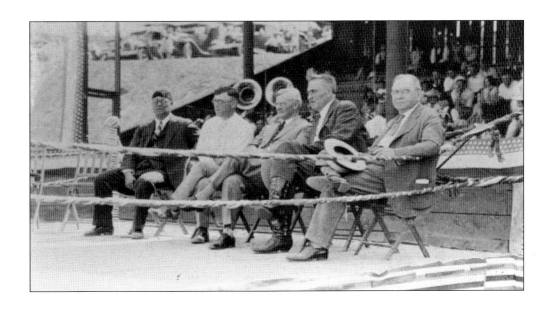

The men in the above image, taken at the Madrid ballpark on July 4, 1930, are, from left to right, VIPs Pete Arris, Oscar Huber, Gov. Richard Dillon, Dr. Brown, and Mr. Fox. These men would have seen a large number of floats, most of them patriotic in nature. The horse-drawn cart pictured below was part of the 1932 parade. A sign on the back of the cart pictured below said "Alabam's gift to Madrid." (Both courtesy Melinda Bon'ewell and Mary Huber Duncan.)

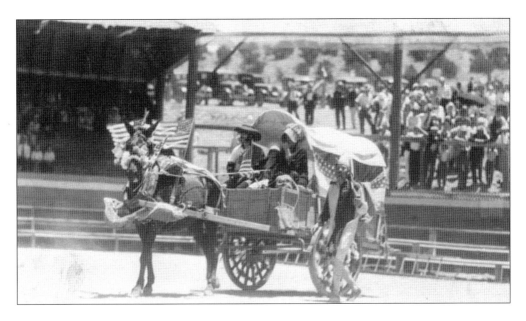

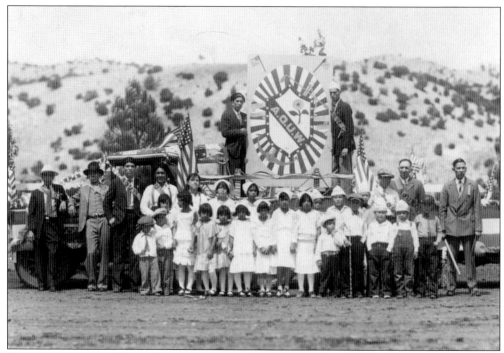

The Ancient Order of United Workmen was a fraternal organization founded in 1868 to provide social and financial support for workers. The organization's goal was to address difficulties between employers and employees and create a plan beneficial to both parties. This float was in the 1931 Fourth of July parade. (Courtesy Melinda Bon'ewell and Mary Huber Duncan.)

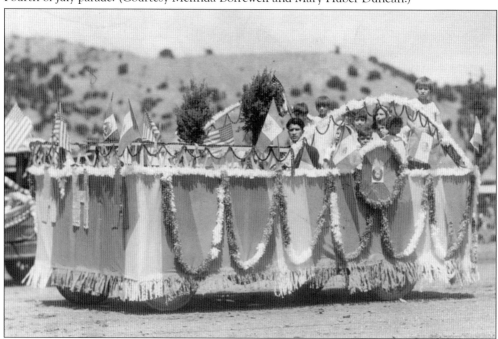

This 1931 AHV float was decorated with flags from both the United States and Mexico. (Courtesy Melinda Bon'ewell and Mary Huber Duncan.)

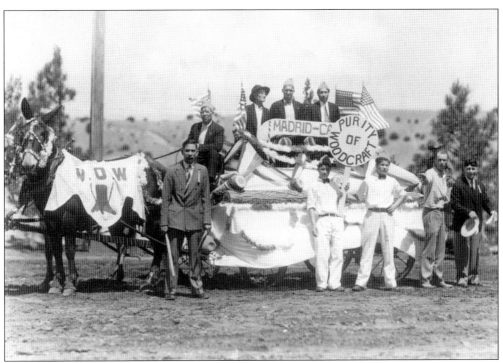

The Woodmen of the World organization participated in many of the Fourth of July parades in Madrid, including this one in 1931. (Courtesy Melinda Bon'ewell and Mary Huber Duncan.)

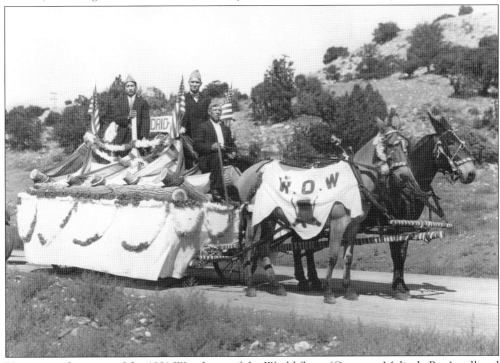

Here is another view of the 1931 Woodmen of the World float. (Courtesy Melinda Bon'ewell and Mary Huber Duncan.)

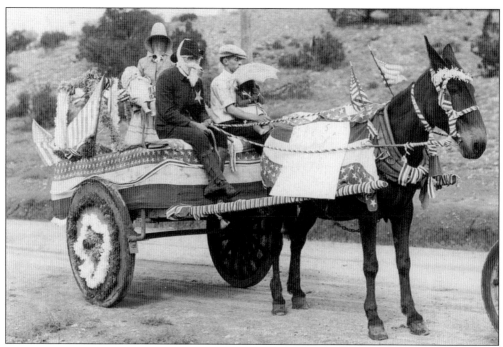

Unfortunately, the sign that identifies the theme of this 1931 parade float is not legible. (Courtesy Melinda Bon'ewell and Mary Huber Duncan.)

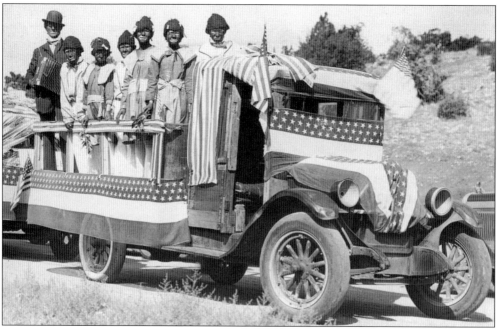

This float was in the 1931 parade. Madrid's current residents have revived the Fourth of July parades. The day begins with a baseball game at the Oscar Huber Memorial Ballpark. The parade starts at noon at the south end of town and ends at the ballpark. The town hosts rodeos at the ballpark and big outdoor cookouts. (Courtesy Albuquerque and Cerrillos Coal Company Photographic Collection, Center for Southwest Research.)

The Madrid Christmas spectacle began in the early 1920s, when a few residents of the town went into the mountains and brought back trees to set up in their yards. For several years, other citizens followed their lead until almost every home had a tree in the yard. Two neighbors decided to create a community nativity, an idea of which Oscar Huber approved. Around 1926, the Madrid Employees' Club decided to make it a community effort. (Courtesy Melinda Bon'ewell and Mary Huber Duncan.)

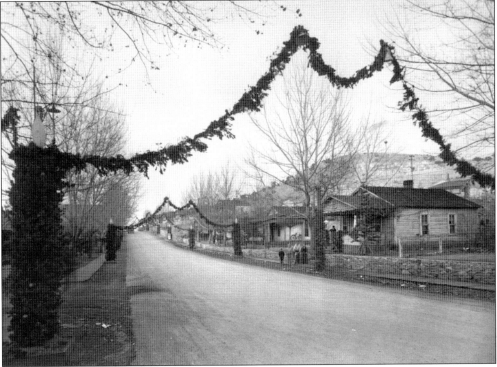

Employees' Club members paid dues of 50 cents to $1.00 a month, supplemented by funds from the Albuquerque and Cerrillos Coal Company. The dues went partially for town celebrations at Christmas and Fourth of July, and the whole community was required to participate in the decorating activities. The Employees' Club started by hanging garlands over the streets and supporting them with evergreen pillars. Next, they decided to portray the story of the birth of Christ in well-lit dioramas on the sides of the mountains. Then, Toyland was created for the children. The display grew more elaborate each year, eventually involving 6,000 square yards of canvas, 23 miles of wire, 1,500 spotlights, and 41,000 colored bulbs. (Courtesy Melinda Bon'ewell and Mary Huber Duncan.)

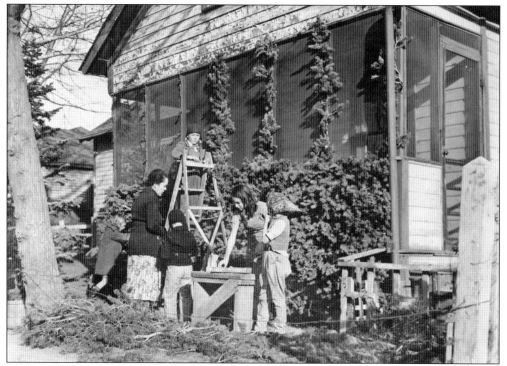

In this image, Mary Gibbs and her children decorate their house for Madrid's upcoming Christmas Festival of Lights. The Christmas display was made possible thanks to contributions of time and labor by every citizen of Madrid. The electricity to illuminate thousands of colored lights and large floodlights was donated by the Albuquerque and Cerrillos Coal Company. (Courtesy Albuquerque and Cerrillos Coal Company Photographic Collection, Center for Southwest Research.)

Oscar Huber justified the expense of the Christmas decorations to George Kaseman, the owner of the Albuquerque and Cerrillos Coal Company, by suggesting that they kept the miners busy and gave them a sense of community. The Christmas display was the most famous of all the Employees' Club activities. (Courtesy Melinda Bon'ewell and Mary Huber Duncan.)

Plywood cutouts were displayed throughout town during Christmas. A 33-foot-tall figure of Jesus stood on the hillside looking over the town. Every fall, the workers would start repainting the cutouts, all of which were spotlighted. The Madrid Old Coal Town Museum still has lighting fixtures labeled for certain cutouts. (Courtesy Melinda Bon'ewell and Mary Huber Duncan.)

This flyer (along with the one on page 80) offers an idea of the scope of the celebration. The "Flower Basket" display stood up to 30 feet high. Oscar Huber loved flowers and gardening—when he moved to Albuquerque after the mines closed in 1954, he hired unemployed Madrid miners to garden there for him. (Courtesy Melinda Bon'ewell and Mary Huber Duncan.)

WHAT TO SEE AT MADRID

CITY OF BETHLEHEM

THE ANGELS

THE SHEPHERDS

THE WISE MEN

JOSEPH AND MARY

NATIVITY SCENE

HUGE COMUNITY CHRISTMAS TREE

LARGE WHITE AND BLUE LIGHTED TREES

SANTA CLAUS AND REINDEER

THE TRUMPETEER

SANTA CLAUS AIRPLANE

FLOWER BASKET

CHURCH OUTLINED IN LIGHTS

TOYLAND

MINATURE SNOW CITY

HOW TO SEE IT

Park your car on a Side Street

NO PARKING ON MAIN STREET

Stop and listen to the Sacred Music coming from the mountain tops.

We are glad to have you with us and wish you a very Merry Christmas and a Happy New Year.

WHAT TO SEE AT MADRID

THE CITY OF BETHLEHEM, WITH THE BLAZING STAR.

THE ANGEL, APPREARING OUT OF THE DARKNESS AND FLYING TOWARD THE HOLY CITY.

THE SHEPHERDS, STARTLED AT THE APPEARANCE OF THE ANGEL.

THE THREE WISE MEN, ON THEIR HUNT FOR THE CHRIST CHILD.

THE NATIVITY SCENE, WITH THE LIVE ANIMALS.

THE HUGE CHRISTMAS TREE, WITH ITS FIFTEEN HUNDRED LIGHT BULBS AND SANTA CLAUS CABIN FROM WHICH PRESENTS WILL BE DISTRIBUTED TO ALL CHILDREN OF MADRID ON CHRISTMAS MORNING.

SANTA CLAUS AND REINDEER AND JINGLING SLEIGH BELLS ON TOP OF THE SCHOOL HOUSE.

THE BUGLER, OUTLINED IN NEON LIGHTS.

SANTA CLAUS AIRPLANE, HIGH IN THE HEAVENS, OUTLINED WITH LIGHTS AND WITH WHIRLING PROPELLER.

THE FLOWER BASKET, A BEAUTIFULL SIGHT.

THE CATHOLIC CHURCH, OUTLINED IN LIGHTS WITH THE BLAZING CROSS OVERHEAD.

THE LARGE WHITE AND BLUE CHRISTMAS TREES.

THEN STOP AND LISTEN TO THE SACRED MUSIC COMING FROM THE MOUNTAIN TOPS.

THE WAY TO SEE EVERYTHING TO BEST ADVANTAGE IS TO PARK YOUR CAR AND WALK, BEING CAREFUL NOT TO PARK ACROSS A PRIVATE DRIVEWAY. WE DO NOT HAVE PARKING LIMITS IN MADRID.

WE ARE VERY GLAD TO HAVE YOU WITH US AND WISH YOU A VERY MERRY CHRISTMAS AND PROSPEROUS NEW YEAR.

MADRID EMPLOYEES CLUB.

Each year, the display depicted the complete story of the birth of Jesus Christ in dioramas and oil paintings. The nativity scene included live animals. In 1939, Pierre Ménager created a 33-foot-high figure of Christ to sit on the hillside; the figure's halo was too big to fit through an ordinary doorway, and it took 40 men to set it up. (Courtesy Melinda Bon'ewell and Mary Huber Duncan.)

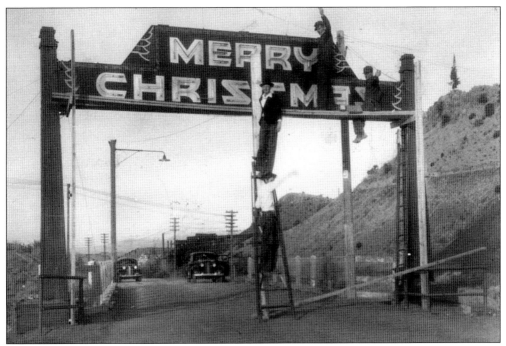

People who once worked in the mines but had moved away would come back to town before Christmas to help decorate. There was a friendly rivalry between work crews preparing the decorations. (Courtesy Melinda Bon'ewell and Mary Huber Duncan.)

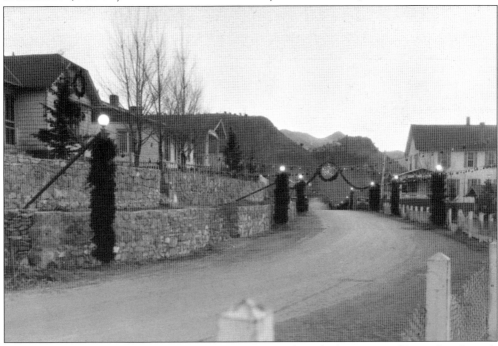

By 1941, the display was lit for about 30 days every year—from the beginning of December through New Year's Day. In 1940, the town contained 350 illuminated outdoor Christmas trees. (Courtesy Melinda Bon'ewell and Mary Huber Duncan.)

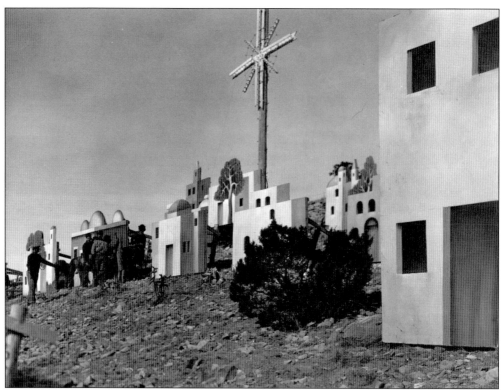

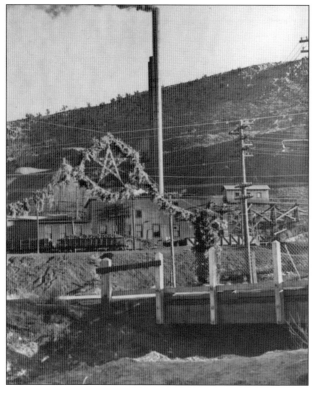

A city of Bethlehem was created every Christmas on the hillside above Madrid. As the displays got more and more elaborate, the human figurines were stuffed to make appear more them three-dimensional. (Courtesy Melinda Bon'ewell and Mary Huber Duncan.)

Even the industrial buildings in Madrid were decorated for Christmas, as shown in this photo. No structure was exempt from the festivities. Lights lined the angles of the Catholic church, and music issued from its doors. (Courtesy Melinda Bon'ewell and Mary Huber Duncan.)

This scene was on the front lawn of the Lamb Hotel in 1934. Three artists worked on the displays: first Paul Lantz, then Carl Von Hassler, and, finally, Pierre Ménager. In 1940, Ménager's work on the Madrid nativity scenes was featured in *Newsweek*. (Courtesy Melinda Bon'ewell and Mary Huber Duncan.)

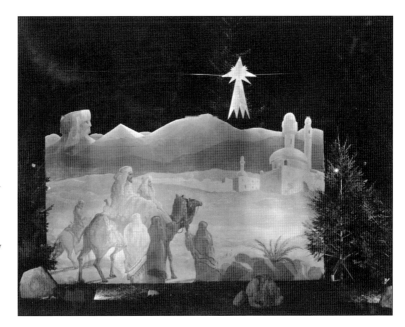

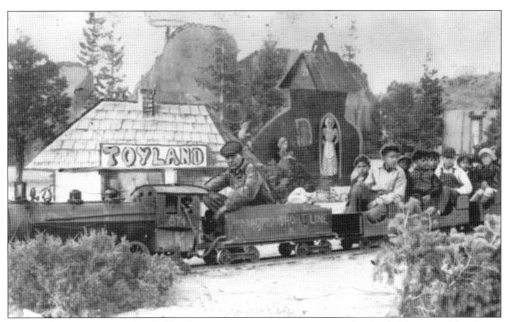

Toyland was set up at the ballpark. A miniature steam train, which children could ride on Christmas day, circled Toyland. Many of the displays were mechanized, such as singing choristers whose lips moved and a Santa Claus and his reindeer pulled across the ground by a belt. (Courtesy Melinda Bon'ewell and Mary Huber Duncan.)

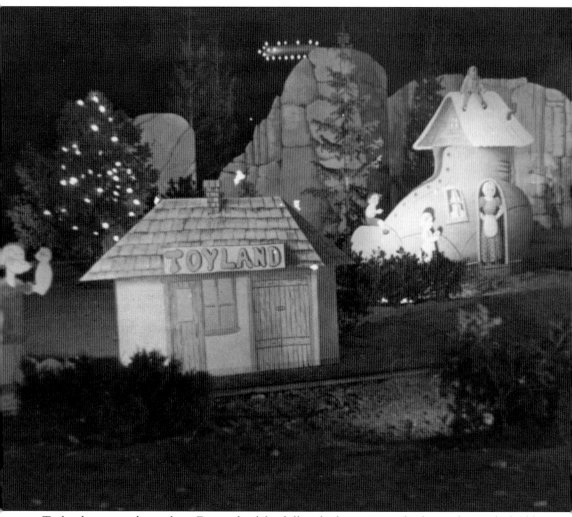

Toyland contained a working Ferris wheel for dolls, which is now on display at the Madrid Old Coal Town Museum. A December 1941 story in *Collier's* magazine about the "Town of Lights" included a photograph of night engineer C.M. Clinard holding up one of the dolls for the camera. Toyland also included a merry-go-round, an airplane, Popeye, the "old woman who lived in a shoe," Little Red Riding Hood and the Big Bad Wolf, and Santa Claus' cabin. (Courtesy Albuquerque and Cerrillos Coal Company Photographic Collection, Center for Southwest Research.)

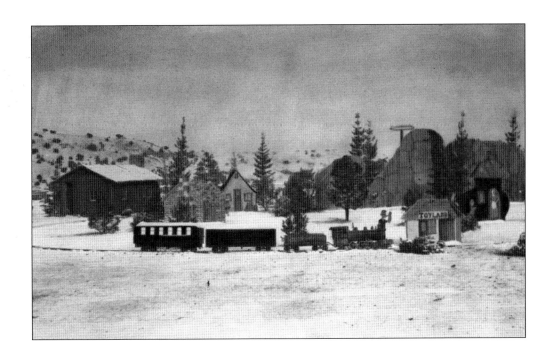

In Toyland, every child received a gift on Christmas morning. A scene from the "birth of Christ" tableau is pictured below. (Both courtesy Melinda Bon'ewell and Mary Huber Duncan.)

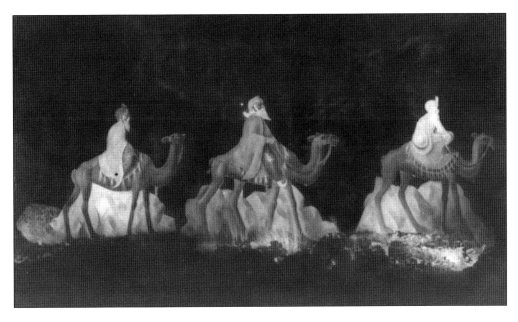

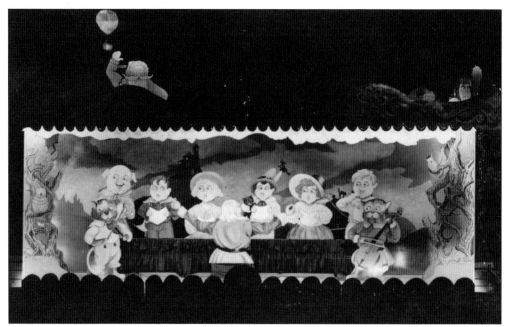

Display creator Paul Lantz had a brother named Walter who was the cartoonist who created Woody Woodpecker. Walter visited Madrid with Walt Disney at least once during Christmas. Some locals believe that Disney got inspiration for the toy trains and lights at Disneyland from the Madrid Christmas displays. (Courtesy Albuquerque and Cerrillos Coal Company Photographic Collection, Center for Southwest Research.)

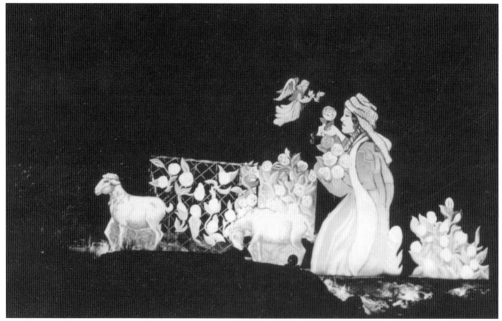

The story of the birth of Christ was depicted in well-lit dioramas displayed on the sides of the mountains. This is one of the scenes, which shows a shepherd watching his flock by night. (Courtesy Nancy Tucker Photographic Collection, Center for Southwest Research.)

More hillside scenes included the city of Jerusalem, the lion and the lamb, and two versions of the town of Bethlehem. In 1940, Gov. John Miles threw the switch to light the displays on Christmas Eve as spectators watched in awe. (Both courtesy Melinda Bon'ewell and Mary Huber Duncan.)

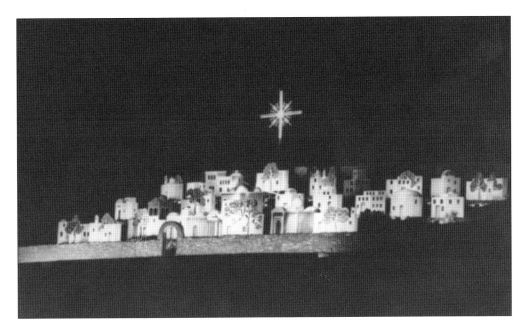

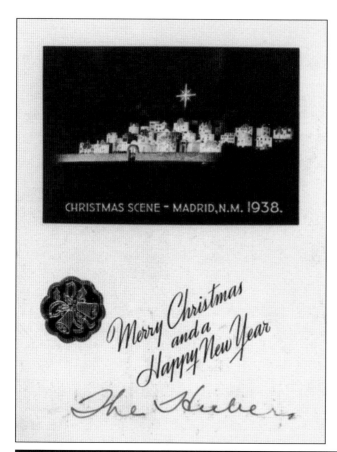

The Huber family's 1938 Christmas card utilized that year's image of the city of Bethlehem. (Courtesy Melinda Bon'ewell and Mary Huber Duncan.)

In 1938, the town of Bethlehem display was 75 feet long and 18 feet high, with a 14-foot-tall star towering above it. (Courtesy Albuquerque and Cerrillos Coal Company Photographic Collection, Center for Southwest Research.)

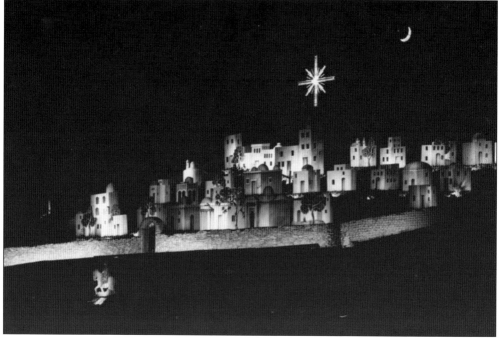

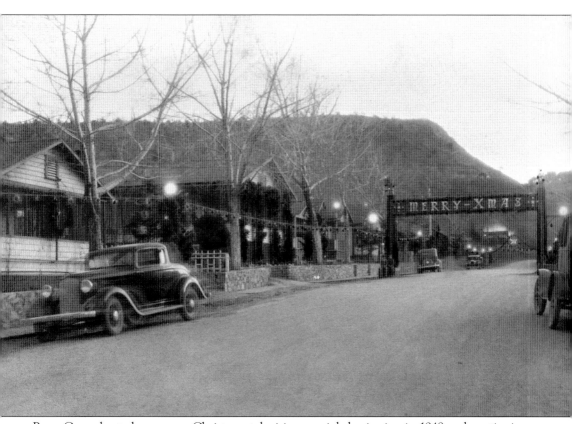

Perry Como hosted numerous Christmas television specials beginning in 1948 and continuing until 1994. They were recorded all over the world and in many locations in the United States. In 1979, decades after Oscar Huber shut down the town, Como did a Christmas special in Madrid based on the memories of people who had lived there. (Courtesy Albuquerque and Cerrillos Coal Company Photographic Collection, Center for Southwest Research.)

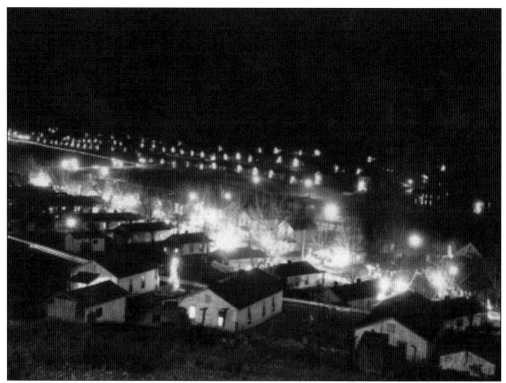

Lights were turned on early and off at midnight. Most townspeople left their doors open during the holiday season, and visitors were welcomed into any home. (Both courtesy Melinda Bon'ewell and Mary Huber Duncan.)

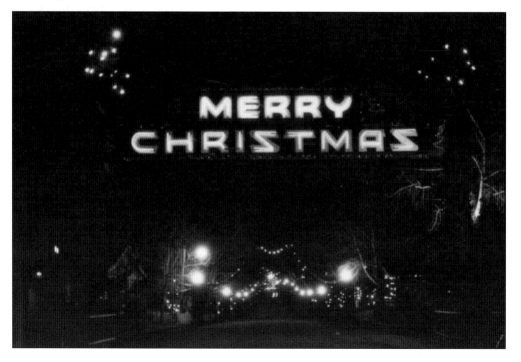

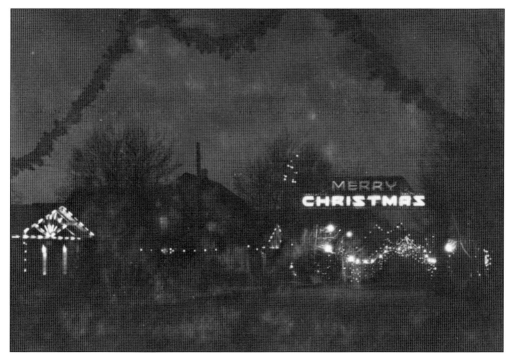

In 1938, an estimated 40,000 lights illuminated the town, attracting about 80,000 visitors—a number that eventually grew to 100,000. Spectators drove through town on State Route 10, which was unpaved at the time. Traveling to witness the Christmas display in Madrid became something of a pilgrimage. (Courtesy Melinda Bon'ewell and Mary Huber Duncan.)

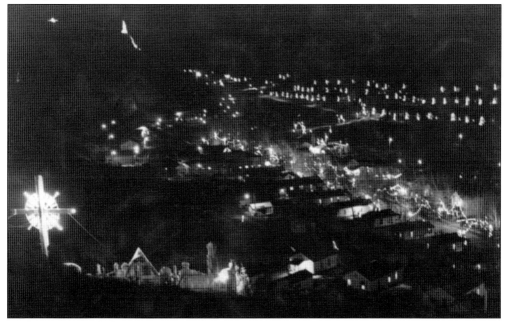

Madrid was called the "Town of Lights." The lighting display covered more than a mile, while the wooden displays numbered 20 pieces and filled four warehouses. (Courtesy Melinda Bon'ewell and Mary Huber Duncan.)

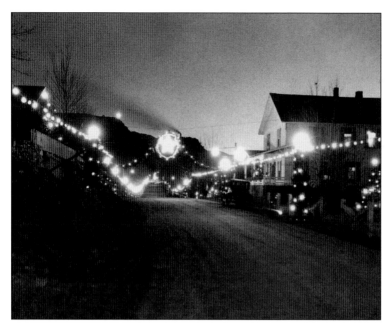

In 1937, TWA captain Theodore Moffitt flew over Madrid on a regular trip to and from Los Angeles and saw the arrangement of lights on the 109-foot-tall Christmas tree on the mountain above town. TWA diverted its transcontinental westbound night flights over Madrid for the rest of the season so passengers could see the display. (Courtesy Bill Henderson.)

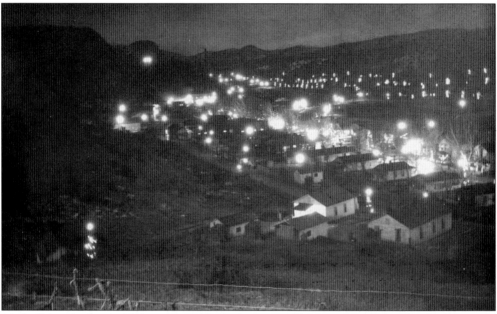

Madrid's last display, in 1941, was arguably the biggest and best ever. On December 7 of that year, just after the lights were turned on, bombs dropped on Pearl Harbor—that was the last time the full display was lit. The lights were shown on a restricted scale in 1942, and in 1943, the city discontinued the spectacle. The decision was in accordance with a national campaign by the Office of War Utilities to discourage the use of lights for community and exterior decorations. One aspect of the celebration that did not end in 1942 was the visit from Santa Claus; Santa gave each child a stocking filled with candy, a toy or game, and a ticket to see a movie on Christmas afternoon. The Madrid Supply Company sold the Christmas decorations to the city of Gallup, New Mexico, for $700; they were later destroyed in a warehouse fire. The town of Madrid has recently revived the Christmas displays. (Courtesy Bill Henderson.)

Three

GOLDEN

The US Cavalry came through the Ortiz Mountains in 1823. They panned for gold in the Arroyo Valverde (the present-day site of Golden), which contained seven live springs. In 1828, placer gold was discovered on the southwest side of the Ortiz Mountains around Tuerto Creek, preceding the discovery of gold in Colorado and two full decades before the California gold rush. Prospectors established two small mining camps—El Real de San Francisco and Placer del Tuerto—in the area. Shortly after these camps were formed, the San Francisco de Assis Catholic Church was built.

The area was worked by individual prospectors for several decades. Between 1832 and 1835, $60,000 to $80,000 in gold was produced annually by the Ortiz mines. Large mining corporations, including the New Mexico Mining Company, came to the area later in the 19th century. However, water was scarce in the area, which hampered mining efforts.

Golden was founded in 1879, encompassing both of the original camps, and a post office was established in 1880. The San Francisco de Assis Catholic Church was soon neighbors with a school, the usual ubiquitous saloons, and a stock exchange. The gold began to play out by 1884, but mining continued on a small scale into the 1890s. Golden's population dwindled, and the post office closed in 1928. Although it is now known as a ghost town, Golden was never completely abandoned. Ernest Riccon opened the Golden General Merchandise store in 1918, and it has been continually in operation ever since. He sold it to his daughter and son-in-law, Vera and Bill Henderson, in 1962.

In 1897, the 69,000 acres of the Ortiz Mine Grant, which included Golden, were sold for $1.5 million. George William Potter Sr., the owner of a small mining company, bought the grant in 1947; he saw an ad for an auction in the paper and was the only bidder. Everyone living on Ortiz grant lands was a squatter. Potter closed some mines and discontinued prior lessees. He evicted most of the squatters and settled with the Santa Fe Dredging Company (which had gold mining operations at Golden) but ignored the town of Golden. Potter eventually sold the town to Bill Henderson, who still operates the Golden General Merchandise store.

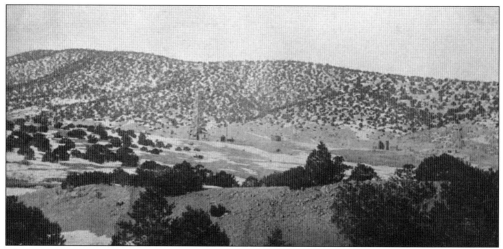

This 1895 photograph shows Golden from the west side of town. (Michael) Harold's well is left of center, and the San Francisco de Assis Catholic Church is to the right. In 1828, prospectors discovered placer gold at Tuerto Creek, on the southwest side of the Ortiz Mountains. Two mining camps arose in the area—El Real de San Francisco and Placer del Tuerto. The San Francisco de Assis Catholic Church was built around 1830. By the 1840s, around 4,000 people reportedly lived in the area. A new community named Golden formed south of Tuerto, absorbing both of the original camps. Golden got a post office in 1880. The post office was discontinued in 1928, but the US Postal Service still allows residents to list Golden as their mailing address. (Courtesy Bill Henderson.)

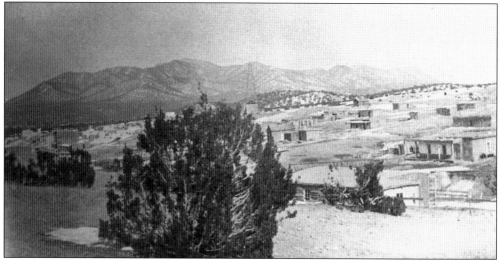

This 1895 view of Golden looks north towards the Ortiz Mountains. The area was deforested by people cutting trees for firewood. Ernest and Lucy Riccon purchased the building in the right middle ground, with the portal across the front, in 1918 for $450 from the Garbanyas, who left Golden because mining had slowed due to World War I, and stores in the area were struggling to survive. Ernest got the money to purchase the building as restitution for being hurt in the Morgan Jones Mine in Madrid. In 1927, Ernest had Golden resident Frank Schmit construct a new building attached to the south side of the original store. It was built with bricks from a factory located in Tonque, a town west of Golden and north of Hagan. The coal mined at Hagan (now a ghost town) was used to fire the furnaces at Tonque. (Courtesy Bill Henderson.)

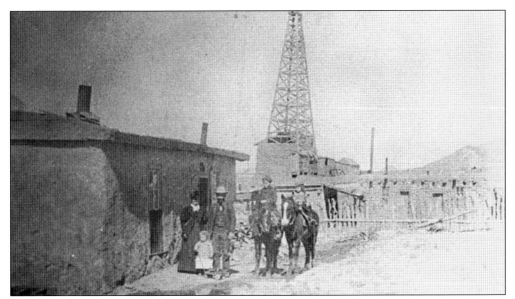

Charlie and Minnie Dean are pictured here with their family in 1895. Minnie Dean was still alive in 1964. This water well (Michael Harold's well) was located near the church and pumped 60 gallons per minute, 24 hours a day—an amazing thing in the arid Southwest. Another nearby well, the Kelly well, was capable of pumping 80 gallons per minute. The Santa Fe Dredging Company had two wells, which they called the mountain wells, at the Argo Claim, but the buildings are no longer standing. (Courtesy Bill Henderson.)

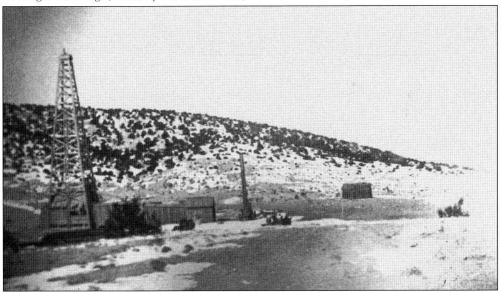

Michael Harold was a well driller who came from the east to drill for water. This 1895 image shows one of the wells he drilled, which became known as "Harold's well." Water was an important element in gold mining. All four of Golden's producing wells were drilled to aid mining operations: two mountain wells leased by the Santa Fe Dredging Company; the Kelly well, which Harold redrilled and the dredging company owned; and Harold's well. There was a fifth well, but its location has been lost to time. Harold's well was used for the mine office, the power plant, and for mining operations in Old Timers Gulch. (Courtesy Bill Henderson.)

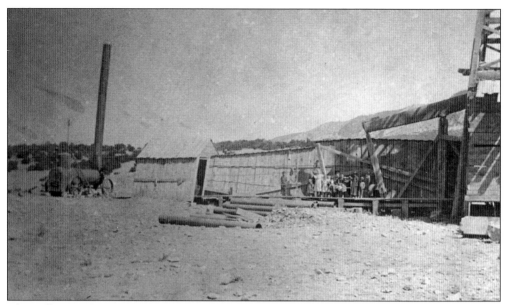

The well tower for Harold's well is at right, and at left is a steam engine that furnished power to drill the well. Note the large group of children in the photograph; perhaps drilling served as their entertainment. (Courtesy Bill Henderson.)

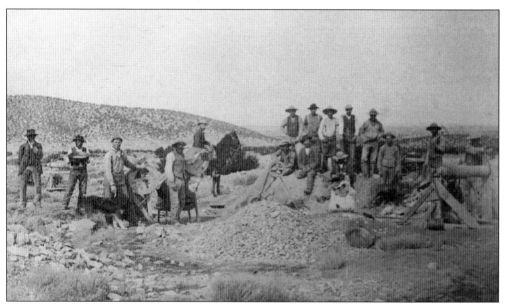

These men panned for placer gold in 1895 at the north end of Golden. The windlass at right lowered the men into the shafts—they would dig down until they hit gold-bearing gravel, then they would branch out. If it got too dangerous to enter the shafts, they would dig in another area. The shafts often caved in, and Bill Henderson says there is no telling how many people were injured as a result. (Courtesy Bill Henderson.)

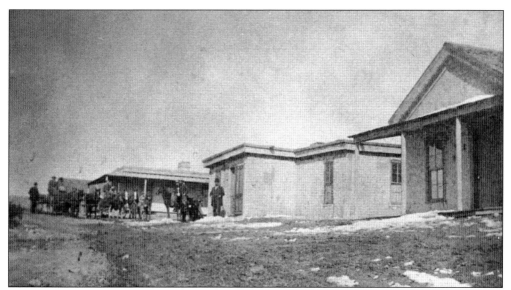

This 1895 image shows Michael Harold standing in front of his home. The building on the far right is still standing in Golden. Gold mining ceased during World War II because it was a nonessential commodity, and many people who decided to move out of Golden disassembled their houses and took them with them. Some of these homeowners rebuilt in Albuquerque's Old Town. (Courtesy Bill Henderson.)

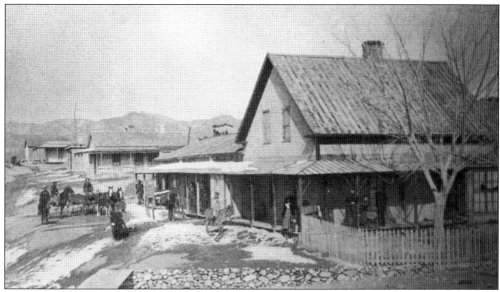

This 20-room bunkhouse, pictured in 1895, was operated as a hotel by the Clark family. It was located north of the church on the east side of the road when the Turquoise Trail was west of its present location and lower down in the arroyo. It was on the edge of an arroyo; the rock wall terracing is to prevent erosion. The hotel got a lot of business. Harold Dean is sitting on a burro in front of the porch. (Courtesy Bill Henderson.)

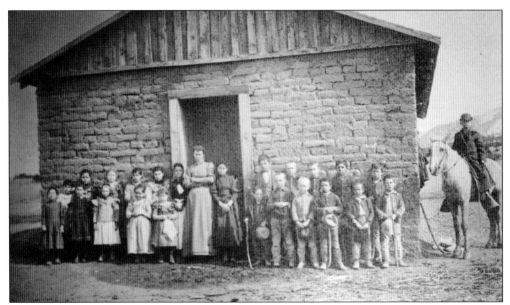

The first Golden school, pictured around 1888, was made of adobe bricks called *terrones* that were cut directly out of the ground with a plow. The school was located just east of the Golden General Merchandise store. After the school burned down, it was moved to the other side of the road into a rock house. Ethel Dean is pictured third from left in the front row, and Harold Dean is on the horse. Vera Riccon Henderson taught in a different school building for part of a year when the teacher got sick; the building she taught in still stands across the street from Golden General Merchandise. (Courtesy Bill Henderson.)

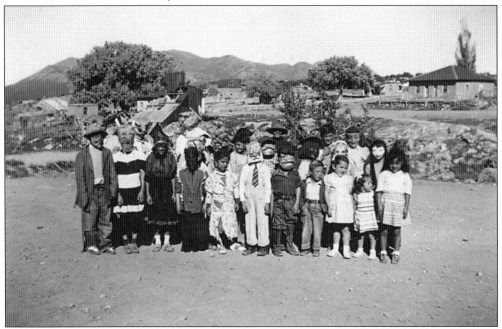

These Golden children, pictured on a Halloween day in the 1950s, appear ready to trick or treat. The stone building at right housed the school after the adobe building burned. (Courtesy Bill Henderson.)

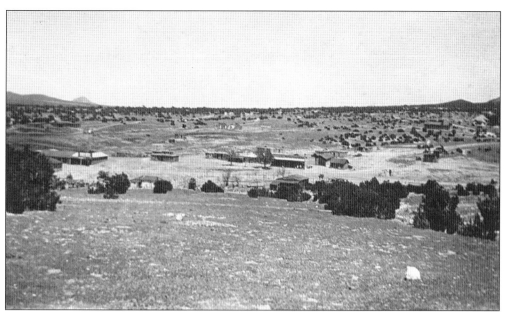

This overview of Golden centers on the store. The Turquoise Trail, which was then known as State Route 10 (the route number was later changed to 14), threads between the buildings across the center of the photograph. (Courtesy Bill Henderson.)

The Iverson House was in the first canyon east of Golden—Old Timers Gulch. Richard Iverson was the superintendent of the Argo Mining Company, which was located in Old Timers Gulch on the Las Vegas Mining Claim. In 1940, he purchased the Huntington Mill that was located on the Las Vegas claim. The mill had been used to process much of the ore in the Golden area and was eventually relocated to the Cash Entry Mining Claim north of Cerrillos. (Courtesy Bill Henderson.)

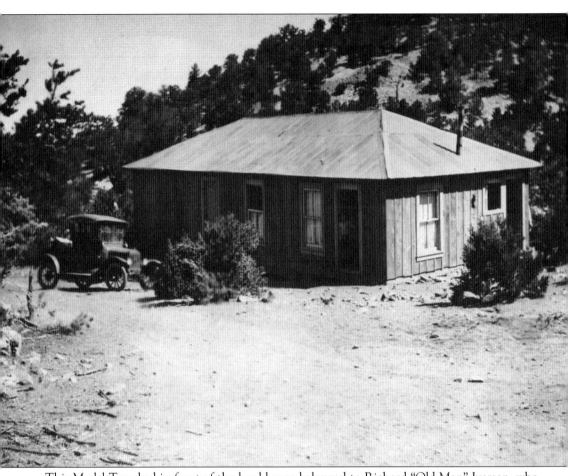

This Model T parked in front of the bunkhouse belonged to Richard "Old Man" Iverson, who then lived in a house in the canyon on the Argo Claim where the two mountain wells were. Iverson was a wealthy man from the east who left his wife and children to come west and quench his gold fever. In 1936, he married Dr. Madoline Breckenridge, who was also from the east. They lived together on the Las Vegas claim. After Madoline's death, Iverson moved to one of Ernest Riccon's apartments. He died in a nursing home in Albuquerque in the 1950s. (Courtesy Bill Henderson.)

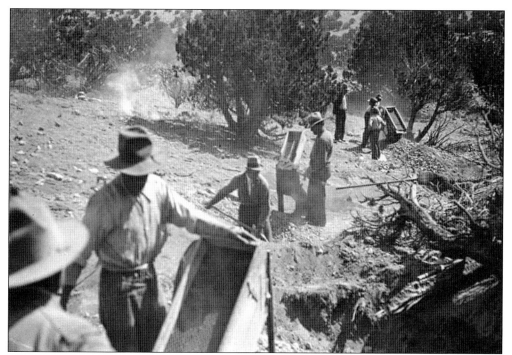

These miners are using dry washers to find gold. Air was puffed upward into the dry washers, forcing the gravel to settle down. The fine particles went through the washer screen, which would then be panned. If a gold nugget was in the washer, it could then be easily picked out. (Courtesy Bill Henderson.)

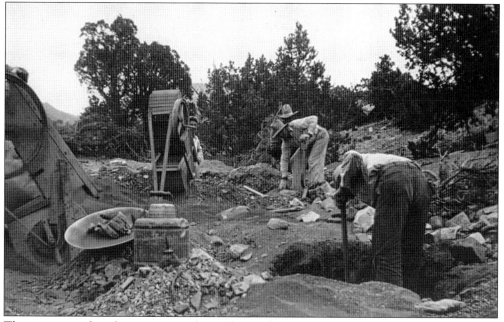

These men are shoveling ore into a dry washer and separating out the gold. Miners carried dry washers all over the area; everyone had one. The dry washers enabled them to go out into the open country and pan for gold with a minimum of equipment. (Courtesy Bill Henderson.)

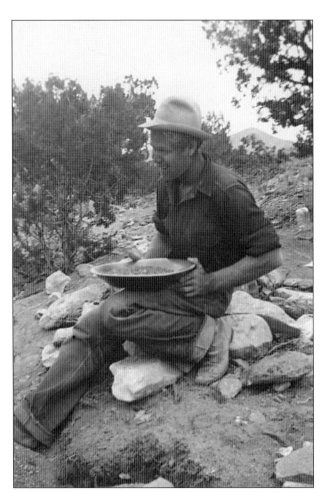

This gold panner is working a claim near Golden. (Courtesy Bill Henderson.)

This miner is digging a shaft for ore to put through his dry washer. Ernest Riccon permitted each miner to dig in a 20-square-foot area, but they could only dig a shaft within that area. Any gold they found had to be sold to the Golden General Merchandise store—Riccon had a license to buy the gold. The store sent 10 percent of the value of the gold to the Galisteo Company (a division of the Ortiz Mining Company), which owned the grant at that time. If the miners did not sell to the store, they got thrown off the land and lost permission to mine there. (Courtesy Bill Henderson.)

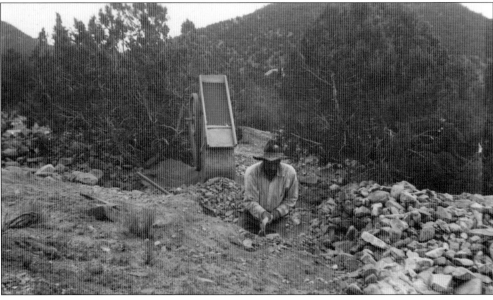

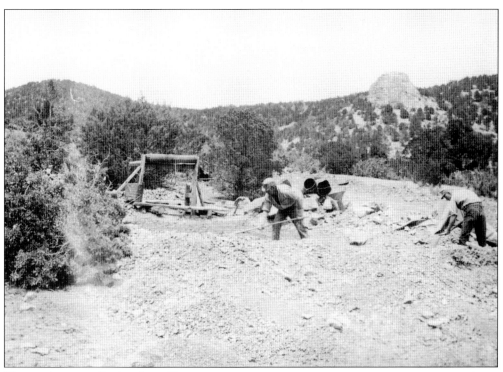

These miners are digging for gold near Golden. (Courtesy Bill Henderson.)

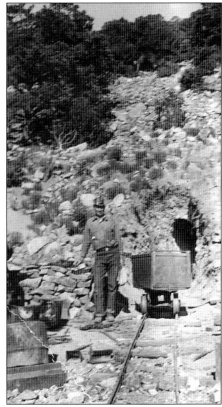

This mine car is pictured at a claim in Old Timers Gulch, the first canyon east of Golden. The car now sits on Bill Henderson's property, along with a prospector's mill. This car was used on the San Francisco claim, which is in the second canyon east of Golden. Ernest Riccon owned the San Francisco claim. It was paying for itself, but Riccon sold it to Johnny Coreliss of Golden. Riccon loaned Coreliss a bunch of gold nuggets to take back east and use to entice potential backers. The San Francisco claim is located on land owned by the Bureau of Land Management, making it a "located" claim rather than a patented claim. Each year, $100 worth of assessment work must be performed on it and recorded in order to maintain ownership. The mine has not produced anything since Coreliss purchased it. (Courtesy Bill Henderson.)

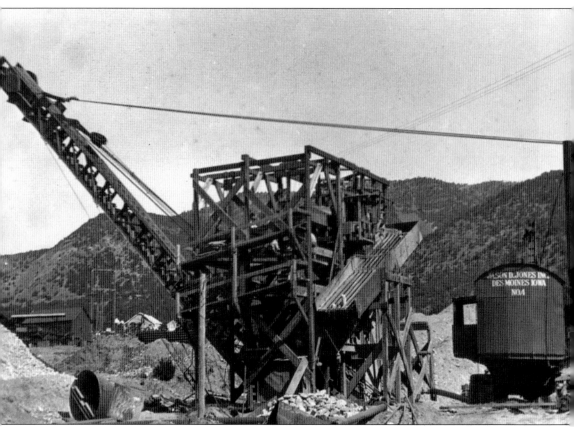

Jason D. Jones was the chief executive officer of the Santa Fe Dredging Company. They were mining placer gold in Old Timers Gulch, the first canyon east of Golden. The Santa Fe Dredging Company filed for incorporation on April 22, 1911, listing their headquarters as Golden. This photograph was taken in 1927. (Courtesy Bill Henderson.)

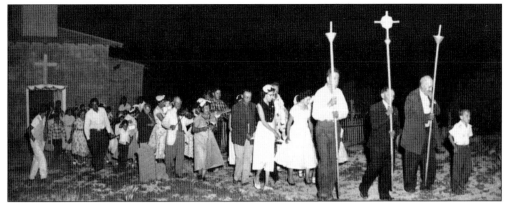

This October 4, 1957, service at the San Francisco de Assis Catholic Church was part of the congregation's yearly Fiesta de San Francisco de Assis. The church was built around 1830 and served as a community center. Despite the fact that the church was part of the Ortiz Mining Grant, a Golden family that did not own the church gave it to a group of California nuns—the Sisters of Charity. It eventually became part of the diocese of Santa Fe. (Photograph by J. Hughes of Ozona, Texas; courtesy Bill Henderson.)

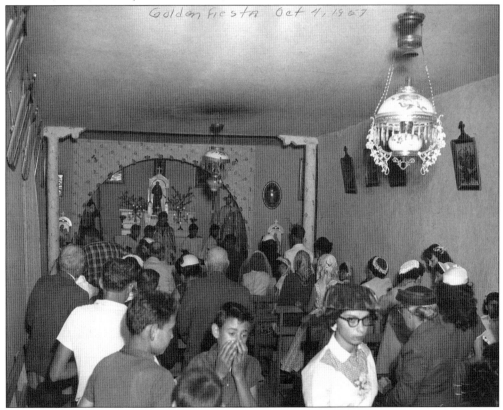

This crowd is attending the mass that was celebrated in connection with the Golden fiesta on October 4, 1957. The chandelier hanging from the ceiling at top right was promised to Bill Henderson in return for installing electricity in the church, but by the time Henderson got around to doing the job, someone had stolen all the interior fixtures. Electricity did not arrive in Golden until the late 1950s. (Photograph by J. Hughes of Ozona, Texas; courtesy Bill Henderson.)

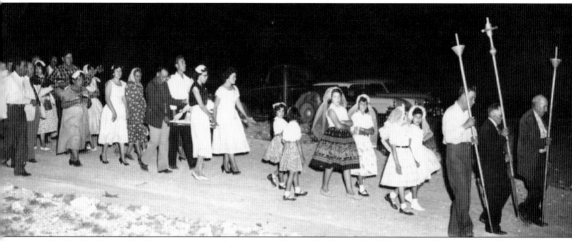

Golden's Fiesta de San Francisco de Assis is always held on the first Saturday in October. The annual fiesta began with Mass, followed by a procession led by Matachines dancers. Bonfires lit the way as the procession wound around the area, blessing the graves in the cemetery and eventually returning to the church. This ritual has roots in medieval Spain. (Photograph by J. Hughes of Ozona, Texas; courtesy Bill Henderson.)

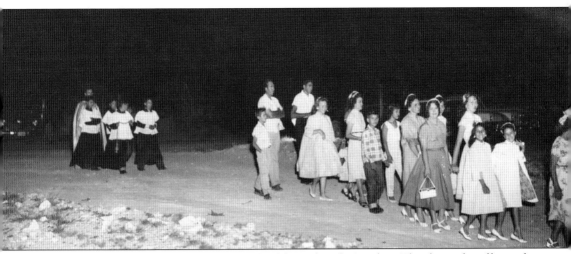

The Fiesta de San Francisco de Assis is still celebrated each October. Thanks to the efforts of Golden resident Michael Montaño, the church has been rehabilitated and holds services every Saturday afternoon. (Photograph by J. Hughes of Ozona, Texas; courtesy Bill Henderson.)

In this photograph from the early 1940s, Bill Henderson and a woman with the last name Cohen sit on the running board of her mother's car in Madrid. Henderson's mother's family relocated to the area when the railroad came in 1890. Her grandfather worked for the railroad as a miner before there were any houses in Madrid and lived in a tent with a wood floor built up against a rock near a spring just outside of Madrid. The entire family later moved into town. Around 1909, John L. Henderson, Bill Henderson's father, moved with his family to Lake Arthur, New Mexico, from Baxter County, Iowa. After World War I, John L. Henderson moved to Gallup, where he drove a steam-powered produce delivery truck for George Kaseman. Kaseman then sent him to Madrid to deliver and to teach others to operate the donkey engine that is now in the Madrid Old Coal Town Museum. Bill's parents met in Madrid when his mother, Sybil Liess, was teaching school and his father was the outside foreman for the Madrid mine. (Courtesy Bill Henderson.)

The Golden General Merchandise store is at left in this photograph, with the camera pointing south down State Route 10. At this time, the store had gas pumps. Route 10 connected Albuquerque and Santa Fe and was dirt and gravel until the entire road—except for the stretch between Golden and Madrid—was paved sometime in the 1940s. The Golden-to-Madrid portion was finally paved in 1960. Route 10 was renumbered State Route 14 in the early 1970s to avoid confusion with Interstate 10 in southern New Mexico. (Courtesy Bill Henderson.)

In 1937, Ernest and Lucy Riccon built these apartments north of the Golden General Merchandise store. A log cabin also stood about 12 feet behind the store, as well as another building behind the cabin. The Riccons attached these buildings to each other, and Ernest ran a bar there. The Riccons raised eight children and two grandchildren in Golden; their daughter Vera married Bill Henderson in 1949. This photograph is from the late 1940s or early 1950s. (Courtesy Bill Henderson.)

This image, taken inside the Golden General Merchandise store, shows Ernest and Lucy Riccon holding their granddaughter, Desiri Henderson, who was born in March 1953. Today, Desiri and her husband, Allen Pielhau, help her father Bill Henderson run the store, and instead of foodstuffs, they stock the store with the best in local Native American jewelry and crafts, making it a popular shopping destination on the Turquoise Trail. Bill Henderson lives in the house attached to the store, which he built for his wife over a 10-year period. His daughter and son-in-law live just north of the store. (Courtesy Bill Henderson.)

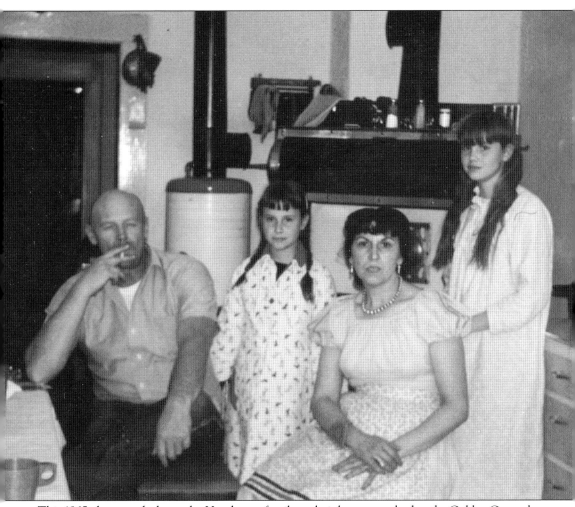

This 1965 photograph shows the Henderson family at their home attached to the Golden General Merchandise store. They are, from left to right, Bill, Desiri, Vera, and Johnna. Vera always wanted the store owned by her father, Ernest Riccon. Ernest would grubstake the Native American laborers when they were working in the bean fields, ranches, or mines in the Golden area. The prospectors would come into the store on a Monday and get enough food to last a week, then the ranch or mine managers would pay them with a chit that they could spend at the store. When farming became mechanized and irrigated and the mines closed down, jobs became scarce. In 1962, when the Riccons could not take care of it any more, Ernest put the store up for sale, and Bill and Vera bought it from him. Vera always admired the Native American jewelry and crafts, and soon after taking over the store, she began trading groceries and household items for them. Despite never advertising, Vera made the store very successful. In this image, she is wearing a Native American bracelet and ring. (Courtesy Bill Henderson.)

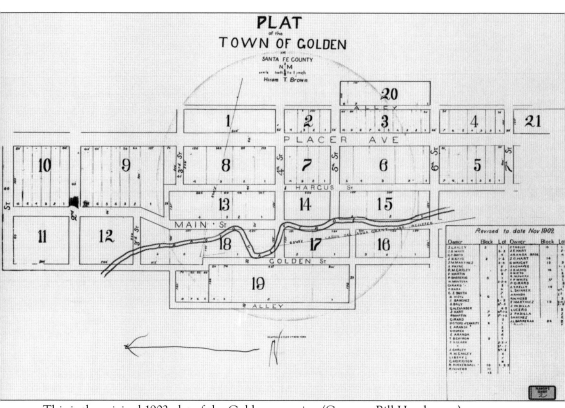

This is the original 1902 plat of the Golden townsite. (Courtesy Bill Henderson.)

Four

THE REST OF THE TRAIL

The Turquoise Trail is 65 miles long and meanders from the ancient city of Santa Fe to the small community of Tijeras. Much more than a scenic drive, the trail is a trip through New Mexico's varied history and its unique offerings. The Turquoise Trail links the famous mining towns of Cerrillos, Madrid, Golden, and others while introducing travelers to other facets of the past and the present: railroads, company towns, artists, and grassroots entrepreneurs—all are part of the Turquoise Trail's complex fabric.

This area's geology remains inexorably linked to the trail's history. Natural resources such as zinc, turquoise, manganese, garnets, coal, gold, silver, copper, lead, and timber—along with the area's natural beauty—first attracted outsiders to the region. The northern end of the Turquoise Trail intersects with the geologic formation known as the Garden of the Gods: upended sandstone and mudstone beds of the Galisteo Formation. The Garden of the Gods is part of the Dakota Wall formation, nicknamed the "Backbone of the Rockies," which runs from Mexico to Canada.

Archaeology and history are also significant at Garden of the Gods. Inhabitants of San Marcos Pueblo farmed and hunted there centuries before the area was "discovered" by other cultures. Spanish conquistadors rode over the hills adorned with pinon and juniper and past the rock formations. Stagecoaches rattled past streams and up arroyos. Highwaymen stalked their prey there, attacking prospectors and miners taking ores from the Cerrillos Mining District to Santa Fe. The remembrance of these dastardly deeds is preserved in the name given to the northern end of the Garden of the Gods—Ambush Rock.

The lure of the Turquoise Trail is still evident today. Locals enjoy hiking, skiing, and camping in the Sandia Crest area, and tourists can try their hands at panning for gold or painting the ancient landscape. Visitors can also simply enjoy a pleasant Sunday afternoon drive in the "Land of Enchantment."

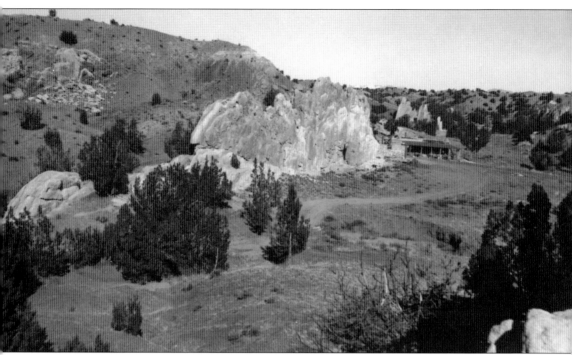

This is the northern end of the Garden of the Gods, an early Cretaceous–era rock outcropping that runs for about three miles along the Turquoise Trail and ends just north of Cerrillos. A break at this end of the formation made a natural passageway for the road between Santa Fe and Albuquerque. Legend says that bandits waited here to rob travelers, which led to naming this slab of yellow sandstone Ambush Rock. In the more recent past, Garden of the Gods Sculpture Center has opened at Ambush Rock. (Courtesy Eldred Harrington Photographic Collection, Center for Southwest Research.)

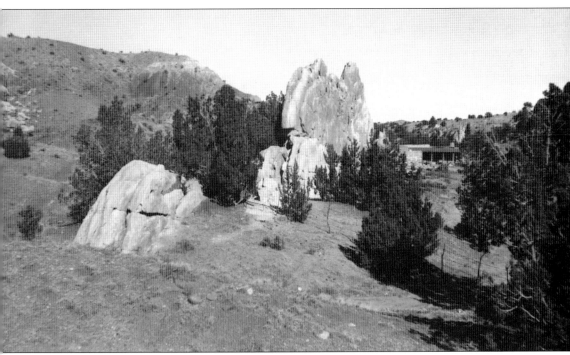

New Mexico's Garden of the Gods is named after its larger cousin in Colorado Springs, Colorado. The two formations are sedimentary rocks of the Dakota Group, which is part of the Dakota Wall ("Backbone of the Rockies") that runs from Canada to Mexico. It was formed by deposits of sandstone and mudstone in the Galisteo Formation, which was tilted to a vertical position by the forces that formed the Rockies millions of years ago. (Courtesy Eldred Harrington Photographic Collection, Center for Southwest Research.)

The exact location where this photograph was taken on the Turquoise Trail is unknown, but the area is rich with fascinating rock outcroppings like this one. This photograph dates to 1939 or earlier, since that was the last year a Plymouth convertible coupe had a rumble seat. (Courtesy Albuquerque and Cerrillos Coal Company Photographic Collection, Center for Southwest Research.)

Here is another outcropping of unknown provenance along the Turquoise Trail; the flat sandstone slab at far left suggests this pinnacle is part of the Garden of the Gods. (Courtesy Eldred Harrington Photographic Collection, Center for Southwest Research.)

This formation is commonly called Devil's Throne. The 200-foot-high cliff is about a half-mile northwest of Cerrillos beside the Atchison, Topeka & Santa Fe Railway line and near the Waldo Canyon Road. Bill Henderson recalls watching the railroad's attempt to blow up Devil's Throne to use the material as base for the railroad tracks in November 1939; the workers tunneled under the rock outcropping and set the explosives. Half of Madrid turned out at the cemetery to watch the blast, as it was rumored to be the largest charge ever set off in the United States up until that time. Twenty-eight thousand pounds of explosives caused quite a noise, but the material turned out to be too soft to use. An advertisement for Atlas Explosives in the *Engineering News-Record* from November 9, 1939, boasted that "Devil's Throne weighs 150,000 tons less after this blast with Atlas Explosives!" (Courtesy US West Landscapes Photographic Collection, Center for Southwest Research.)

Gold was found in San Pedro (pictured) by 1846. In 1880, the San Pedro and Canon del Agua Company started full-scale operations, and a townsite was laid out. The company opened a copper mine in the area, but legal issues over mineral rights closed the mine. In 1887, gold was found again, and the smelter was reopened. In 1889, the Santa Fe Gold and Copper Company bought the property. As at Golden, when mining played out at San Pedro, some owners moved their houses to Albuquerque. (Courtesy Eldred Harrington Photographic Collection, Center for Southwest Research.)

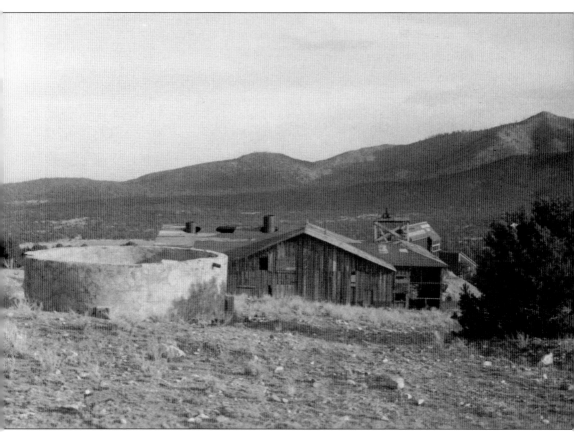

This image of San Pedro gives little indication that it was once a bustling mining camp. W.S. Carnahan mined in the San Pedro area during the late 1920s, and a store and post office were reestablished between 1927 and 1930. The last big copper strike in San Pedro was in the 1930s by Rascob Inc. Rascob sold the San Pedro Mine for $25,000 to a mining engineer named Williams. Mining continued through World War I, but after the war, the price of copper dropped, and the smelter burned. It was never rebuilt. (Courtesy Eldred Harrington Photographic Collection, Center for Southwest Research.)

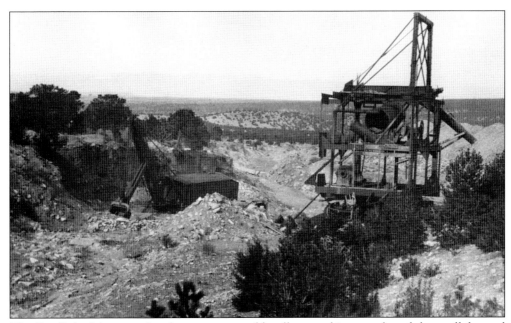

The San Pedro Mine is so big that a person could walk around its tunnels and slopes all day and not take the same path twice. Bill Henderson mined copper in the San Pedro mine in 1949 and 1950, after he returned from being a carrier pilot in World War II. His wife, Vera, had purchased a lease on it for him. (Courtesy Bill Henderson.)

The ruins of these coke ovens are located on private property at the site of San Pedro. Along with a cemetery and some foundations, they are all that is left of the town. (Courtesy Bill Henderson.)

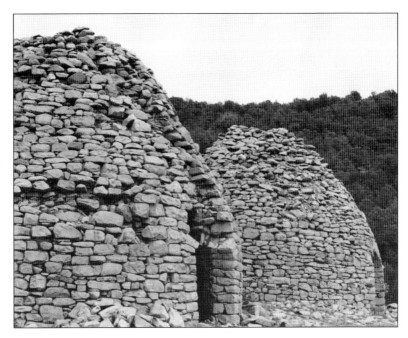

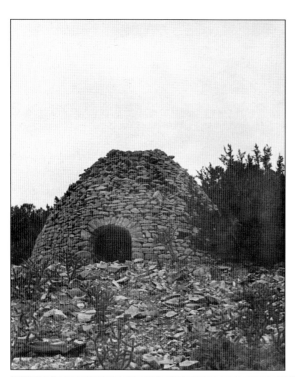

San Pedro's coke ovens were built in the 1800s. (Courtesy Bill Henderson.)

Many people enjoyed taking photographs of San Pedro's coke ovens. (Courtesy Alice Bullock Photographic Archive, Center for Southwest Research.)

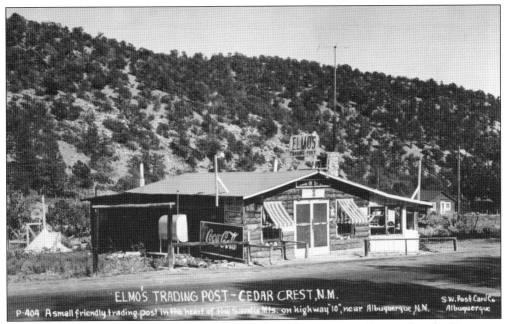

ELMO'S TRADING POST - CEDAR CREST, N.M.

P-404 A small friendly trading post in the heart of the Sandia Mts. on highway "10", near Albuquerque N.M.

S.W. Post Card Co. Albuquerque

Elmo's Trading Post no longer exists in Cedar Crest. The caption indicates that the Turquoise Trail was still State Route 10, and the road looks paved, so this photograph must have been taken between 1949 and the early 1970s. Cedar Crest is located just north of where old Route 66 and the Turquoise Trail intersect. (Courtesy Nancy Tucker.)

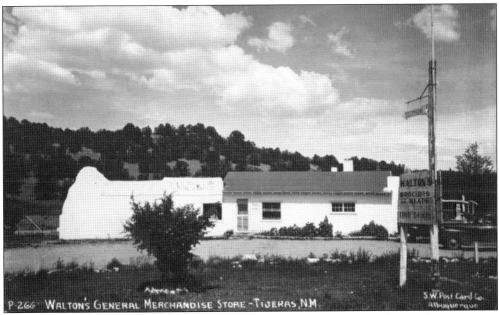

P-266 WALTON'S GENERAL MERCHANDISE STORE - TIJERAS, N.M.

S.W. Post Card Co. Albuquerque

Walton's General Merchandise Store used to operate in Tijeras. Tijeras is the southern terminus of the Turquoise Trail. The cars in this photograph suggest that it dates to the 1940s. (Courtesy Nancy Tucker.)

Ross Ward (1949–2002) stands in front of one of his dioramas in the Tinkertown Museum. Ward moved to the mountains of New Mexico in the 1960s and started his workshop, which eventually evolved into Tinkertown Museum, a unique and exciting stop along the Turquoise Trail. Ward painted signs, often for carnivals, and was also a fine artist and woodcarver. One of his signs in the Tinkertown Museum says: "I did all this while you were watching TV." Ward helped create the original designation of Turquoise Trail for State Route 14 and painted signs up and down the Turquoise Trail National Scenic Byway for over 30 years. Many of his signs are still in use and are recognizable due to his distinctive style. (Courtesy Carla Ward.)

This view from Inspiration Point is on the Sandia Loop Drive. State Route 536 (the Sandia Crest Road) is part of the Turquoise Trail National Scenic Byway. It turns off State Route 14 at Sandia Park (elevation 7,077 feet) and winds through the Sandia Mountains for about 13.5 miles to the crest (elevation 10,678 feet), a climb of 3,601 feet. There are many beautiful vistas like this on the way up. (Courtesy Nancy Tucker.)

The road up to Sandia Crest travels through four different life zones—from desert grassland at its base to spruce and fir at the top. (Courtesy Nancy Tucker.)

Sandia is Spanish for watermelon. The generally accepted explanation for the name is that the mountains have a pinkish color. The pink comes from potassium-feldspar crystals embedded in the granite of which the mountains are composed. However, the Sandia Indians, whose ancestral lands are at the western base of the mountains, believe that the Spaniards who named the mountains thought that the squashes they were growing were watermelons. (Courtesy Nancy Tucker.)

The Sandia Cave archaeological site is located in the Sandia Mountains. The site was excavated in the 1940s by Frank Hibben when he was affiliated with the University of New Mexico. The excavation recovered artifacts associated with extinct mammals. The National Park Service declared it a National Historic Landmark in 1961. The car in the image dates this photograph to the 1930s or 1940s. (Courtesy Nancy Tucker.)

This unidentified cyclist rode 15 miles and up 3,000 vertical feet—this is not a bike ride to be undertaken lightly. (Courtesy Eldred Harrington Photographic Collection, Center for Southwest Research.)

DISCOVER THOUSANDS OF LOCAL HISTORY BOOKS
FEATURING MILLIONS OF VINTAGE IMAGES

Arcadia Publishing, the leading local history publisher in the United States, is committed to making history accessible and meaningful through publishing books that celebrate and preserve the heritage of America's people and places.

Find more books like this at
www.arcadiapublishing.com

Search for your hometown history, your old stomping grounds, and even your favorite sports team.